NEW YORKERS

SALLY DAVIES

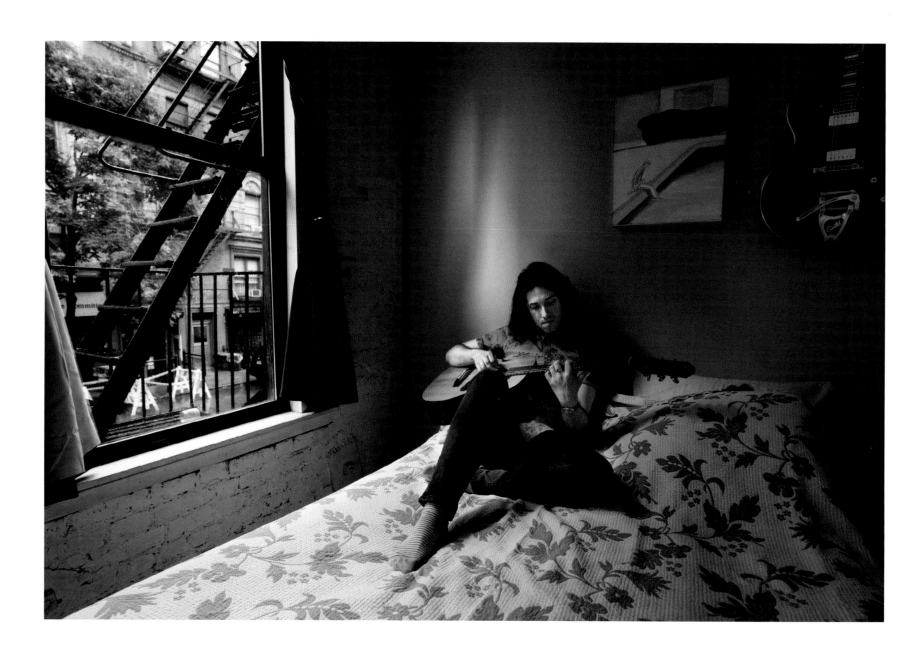

NEW YORKERS

SALLY DAVIES

AMMONITE
PRESS

PREVIOUS PAGE

ASHER LACK

Photographed at his apartment on East 4th Street on June 10, 2019.

Asher was born at home in 1982 in an apartment on East 1st Street that his parents were subletting from Suzanne Mallouk. He is the youngest of two kids for Stephen and Lilly. Mom and Dad were both artists. Asher spent most of his childhood in downtown New York City. They lived in Chinatown. He left home when he was 18 to go to college at the same time that his parents left New York City for upstate New York. Asher plays in a band called Ravens and Chimes, and still lives in the same apartment he's had since 2004.

"Living in New York is such a struggle in so many ways that it forces you to ask pretty fundamental questions about who you are and what you can handle. Growing up here I didn't realize the degree to which I had internalized a lot of these lessons and how much of who I am (and who everyone else here is) has been shaped by that struggle. It doesn't necessarily make you a better person or even a harder, stronger person, but I think it does make you much more equipped to know what you want and go for it unflinchingly. People are always asking me what it's like to grow up in NYC and I tell them this: when I was 13, my dad and I were in the elevator of the Chelsea Hotel and a guy with a black mop top and tight jeans walked in. My dad looked at him and said, 'Don't you look just like Joey Ramone.' The guy's face turned a bit red and he didn't say anything. Then, when he got out of the elevator, I turned to my dad and said, 'Dad, that was Johnny Ramone.'"
—Asher

First published 2021 by
Ammonite Press
an imprint of Guild of Master Craftsman Publications Ltd
Castle Place, 166 High Street, Lewes, East Sussex, BN7 1XU,
United Kingdom
www.ammonitepress.com

Text and images © Sally Davies, 2021
Foreword © Stuart Horodner, 2021

Copyright in the Work © GMC Publications Ltd, 2021

ISBN 978 1 78145 404 6

A catalog record for this book is available from the British Library.

Publisher: Jonathan Bailey
Designer: Robin Shields
Editor: Laura Paton

Color reproduction by GMC Reprographics
Printed and bound in China

Set in Futura

The New Yorkers

Asher Lack	2	Jen Poe	56	Michael Riedel	110
Foreword	6	Rachid Alsataf	58	Penny Arcade	112
Bruno and Maylis Dayan	7	Bara and Roger de Cabrol	60	Frank Andrews	114
Introduction	8	Frances Pilot	62	Flloyd NYC	116
Jack Smead	9	Will Davis	64	Jewel Weiss	118
Suzanne Mallouk	12	Ben Mindich and Montgomery Frazier	66	Matthew Hittinger and Michael Ernest Sweet	120
Claire and Garland Jeffreys	14	Jackie Ferrara	68	Sur Rodney (Sur)	122
Laurie Anderson	16	Mehai Bakaty	70	Betty Tompkins	124
Lois Walden and Margot Harley	18	Janet Halpin	72	Beatrice Moritz	126
Michael Musto	20	Allan Tannenbaum	74	Ed McGowan and Claudia DeMonte	128
Jacquie Tellalian	22	Bruce Mazer	76	Gerald DeCock	130
Carlos "Los" Franco	24	Dolores Kestler	78	Linda Heidinger	132
Sylvia Parker Maier	26	Cherie Nutting	80	James Kaston	134
Charlie Romanofsky	28	Steven Hammel	82	Charlene McPherson	136
Karol Jackowski	30	Steven Salzman and Ellen Kahn	84	Lynne Burns	138
Marina Press Granger	32	Buddy Papaleo	86	Angela Fremont and Harold Appel	140
Sam Swope and Jim Tryforos	34	X Baczewski	88	William Ivey Long	142
Linda Simpson	36	Kate Maxwell	90	Gracie Mansion	144
Liz Duffy Adams	38	Eric Ambel	92	Benny Hansen and Malan Libório Dos Reis	146
Tom Birchard	40	Fred Brown and Claire Flack	94	Iris Rose	148
Theresa Buchicchio	42	Rick Prol	96	Matt Weber	150
Delphine Blue	44	Joyce Pomeroy Schwartz	98	Cressa Turner	152
Pamela Lubell	46	Meta Hillmann	100	Gillian McCain and Jim Marshall	154
Mitchel Bayer and Bea Winkler Bayer	48	James Hammond	102	Danny Fields	156
Vicky Roman	50	Stuart Zamsky and Kim Wurster	104	Sally Davies	158
Noah Becker	52	Maria Heredia	106		
Bijou Clinger	54	Michael McMahon	108	Acknowledgements	160

FOREWORD

by Stuart Horodner

For the past 30 years, Sally Davies has been documenting the streets of Manhattan. Bicycling or walking through the city at all hours, her eye is alert to its evolving dramas. She's watched neighborhoods negotiate with gentrification, post-9/11 anxiety, economic uncertainty, and a steady stream of "if I can make it there, I'll make it anywhere" optimism. Davies has taken memorable photographs of ordinary doorways, wet curbs and corners, the glow of bar-grill signs, bodegas, bakery windows, wheelchairs on rooftops, incoming weather, graffiti, and vintage cars. As she has said, "You either fall in love with moonlight on a garbage bag or you hate it and move along."*

Grounded in the visual vocabulary of legendary practitioners including Diane Arbus, Helen Levitt, and Joel Meyerowitz, her images have a "just the facts" clarity that is combined with cinematic lushness. Each Davies photo captures a particular poetry of place, featuring natural and artificial light, subtle and brash color, and a range of anonymous figures within the built environment.

She started the *New Yorkers* by shifting from her usual view of the urban outdoors to the idea of chronicling the spaces and stories of the natives and transplants who give the city its particular vitality. Twenty-five percent of the people pictured here are familiar to the artist, the remainder were found through various referrals. The subjects sent her a short bio prior to her arrival at their homes. After a few minutes of getting acquainted, Davies assessed the possibilities of body language, clothing, furniture, and objects. She worked quickly, trusting her instincts and staying open to the unpredictable.

In these portraits, you will meet waitresses, musicians, cab drivers, painters, teachers, shopkeepers, writers, designers, producers, parents, a gossip columnist, and a psychic to the stars, among others. They are singularly sensational, and they attest to multiple jobs, friendships, marriages, divorces, children, and pets. Young and old, straight and gay, casual and formal; they pose in cramped kitchens and elegant living rooms, laying on beds, sitting in bathtubs, surrounded by the surfaces and souvenirs of living. There is an abundance of brick, wood, leather, and metal, and collections of refrigerator magnets, religious and street art, books, Pez dispensers, vinyl records, and plants.

These photographs and texts speak to what all New Yorkers understand—to live in this city is to embrace struggle, sacrifice, love, and change. The trials and tribulations are hardwired in, as Iris Rose reports: "Everything is crooked, cracked, bumpy and hard to clean." And there is profound joy, too, when Jen Poe contemplates her midtown space: "It feels like my apartment was handed to me by God."

When I spoke with Davies over breakfast in February 2020, I asked her what this project reveals. She said, "This is the end of an era." That comment has returned to me repeatedly. This book is going to print during a pandemic that has stopped the world as we know it. We are in our homes for hours on end, adapting to new habits, while thinking and feeling deeply about where and how we live. These New York people are right on time.

*Sally Davies in Michael Ernest Sweet's "Photographer Sally Davies Discusses Women Street Photographers," *HuffPost* (December 15, 2015)

BRUNO AND MAYLIS DAYAN

Photographed at their Brooklyn home on January 18, 2020.

Bruno was born in 1959 in London, England. He lived in Montreal, Toronto, Paris, Japan, and finally New York. Bruno is a photographer and he has a son named Noah.

"I love New York City— the energy and chaos, the summer nights when it is so electric and crazy. It is contagious."—Bruno

Maylis was born in 1974 in Colombes, France. She grew up in Paris, taking dance lessons as a little girl, and studied literature later at college. She did some traveling early on, before ending up back in Paris. She has two kids, Laury and Lirann.

"I love living in New York City. This city is so special and energetic. People are much less aggressive if you compare it to Paris. It feels safer here."—Maylis

Bruno and Maylis met at a photo studio in Paris in 2001 and they got married in 2008. They moved to New York City in 2014 and into this apartment in 2018.

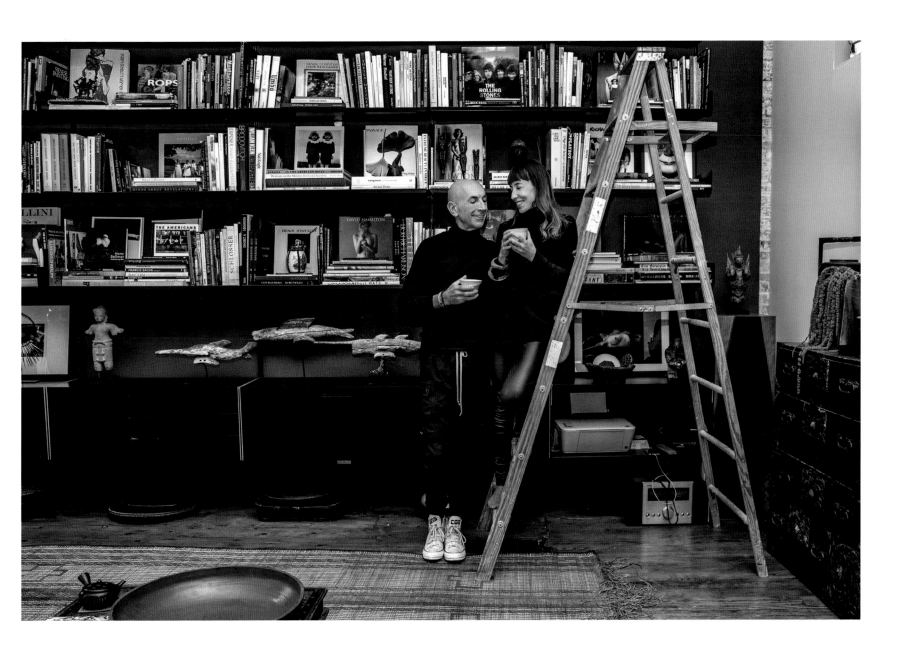

INTRODUCTION

I recently placed several photographs in the permanent collection at the Museum of the City of New York. Things had come full circle. I had photographed the streets of New York City for 35 years and now I knew the images would live on. They would be there for gaggles of school kids to look at on field trips, long after I had left the planet. I thought about cameras as we know them now, and how they would become antiques. I thought about paper prints, and how they too would become an old-school process. I imagined art students looking on, trying to grasp what the city looked like back in these good old days. My photographs would now be part of that story. And so it was, right around that same time, that I woke at 4am from a deep sleep, feeling troubled—no one would ever know who had lived in these buildings that I'd photographed. How did they get there? What did they look like? Where did they work? What hung on their walls? What did they collect? It wasn't unusual to find people in my street photographs, but this would be different; not just some happenstance appearance in an outdoor street shot. No, this would be a portrait of them and I would tell their story. I knew in five minutes what I needed to do. One new lens and two days later, I was on a subway en route to a total stranger's New York City home, to write down their story and take their photo.

The project had wings right from the first day. Everyone knew someone, who knew someone to recommend. So many remarkable people wanted in on the project. Each person that invited me into their home was nothing less than a gift from the universe, and each person's story and how they ended up in New York City was better than the last. Through all the different races, genders, incomes, and ages, there was a string that held them all together—they were New Yorkers, and they really weren't like other people.

We all have a destiny and I believe this book was part of mine-—but as fate would have it, just days after I delivered the final photographs to the publisher, Covid-19 arrived like some viral hurricane. Life came to a screeching halt as New Yorkers went into a mandatory lockdown at home. I am grateful beyond words that a magic door had opened and stayed open, just long enough for me to complete this project. There is just no way I could take these portraits now, as we all continue to stay home and only meet people outside where it's safe. The days of inviting people into our homes are over, and in the blink of an eye these images have become souvenirs of another time.

I hope this collection of New Yorkers props that door open again, just a little, as these people invite you into their home for a very rare visit and to tell you their story.

Sally Davies
www.sallydaviesphoto.com

JACK SMEAD

Photographed at his East Village home on April 12, 2019.

Jack was born in 1948 in Chicago. He was the oldest of two kids for Phylis and Charles. Mom was a housewife and Dad was a traveling salesman. He spent his childhood in South Dakota, where his Mom was from, and they moved back to Chicago when he was a teenager. Jack wanted to be an artist when he grew up. He wasn't that good at the regular school stuff, but he won art awards and he loved music, playing in a band called the Banshees in high school. Between the Banshees and working in a fancy men's clothing shop, Jack saved enough money to go to college at the Chicago Institute of Art, avoiding the draft. When he graduated from college, he left right away for Manhattan. He lived in all kinds of apartments in downtown New York, until he moved into this place in 1978. Jack continues to make music and still lives in this apartment.

"New York City is a place so nice, they named it twice."
—Jack

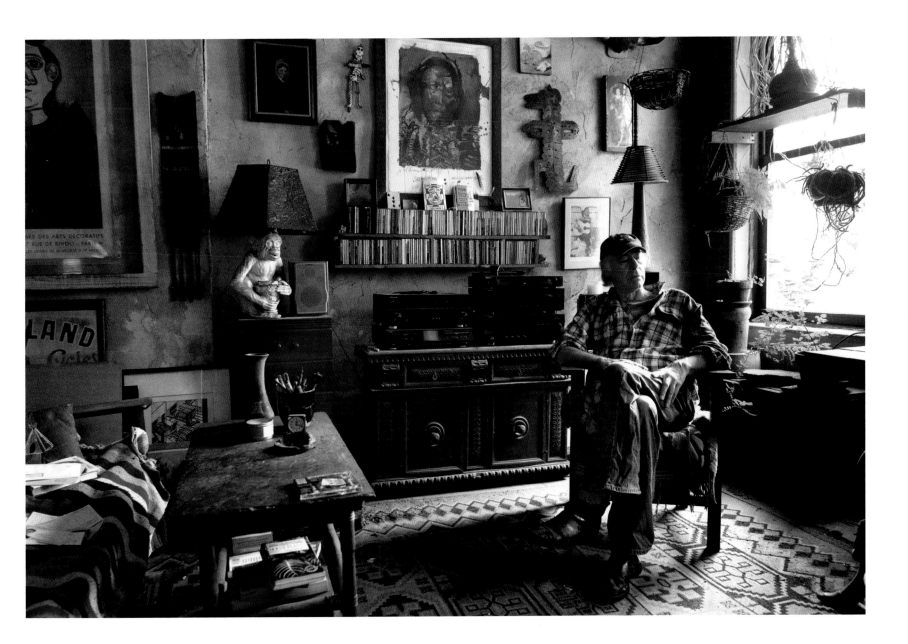

NEW YORKERS

This book is dedicated to Mable Davies.

SUZANNE MALLOUK

Photographed with her dog Bella at her home on Central Park West on May 11, 2019.

Suzanne Mallouk was born in Orangeville, Ontario, Canada, in 1960. She was the third of five kids for Joanna Baird and Hannah Antoine Mallouk. Dad was a Palestinian refugee and Mom was British. At 15 years old she moved to London, Ontario, where she went to art school for two years before heading to the big city of Toronto. It was there she heard about the art scene in the East Village. She bought a ticket as soon as she could and went to New York City, landing an apartment at 68 East 1st Street. She worked as a waitress at Max's Kansas City, a cigarette girl at the Ritz, and then at her next gig, as a bartender at Nightbirds, Suzanne met the love of her life, Jean-Michel Basquiat. In 1981 Jean moved into Suzanne's East 1st Street apartment and made a lot of great art there. About a year later they moved out of that apartment, often sleeping on a mattress in a friend's stairwell in the hot summer months. They also lived for a while at the Algonquin Hotel. When Jean started making money, they moved into a loft on Crosby Street in SoHo in 1982. They lived there for two-and-a-half years. After Jean-Michel died, Suzanne returned to school as a way to transform herself and deal with her grief, attending medical school and becoming a doctor. She is now a psychiatrist and psychoanalyst on the Upper West Side.

"When I first arrived in New York City on February 14 of 1980, I knew immediately it was where I was meant to be. It had a certain gritty, dark elegance that was gorgeous to me and remains so. New York City is like a living organism, always growing and changing. It is a very alive city. The natural rhythm of the city feels synchronous or harmonious to my own. I feel depressed anywhere else."
—Suzanne

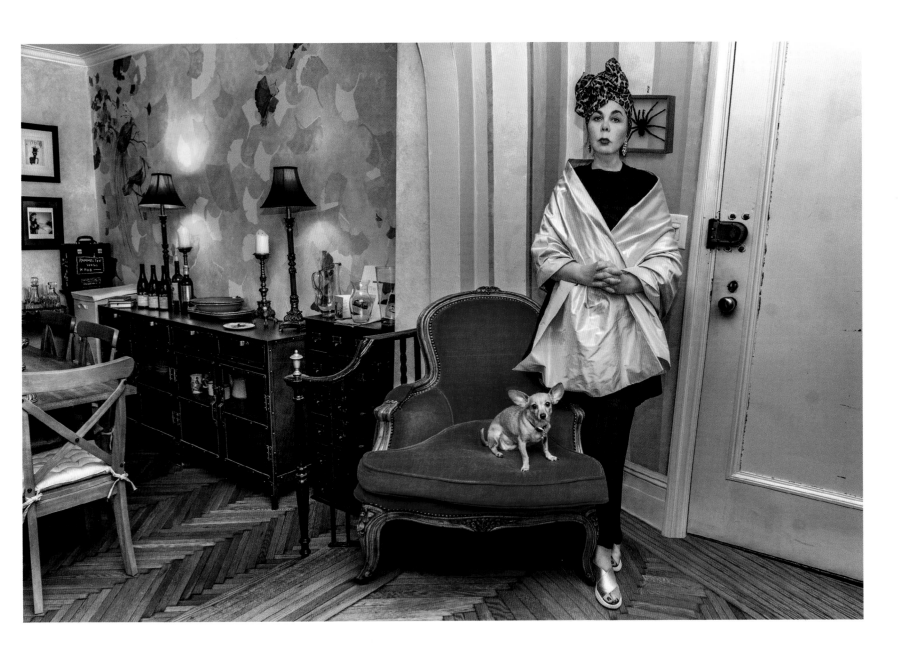

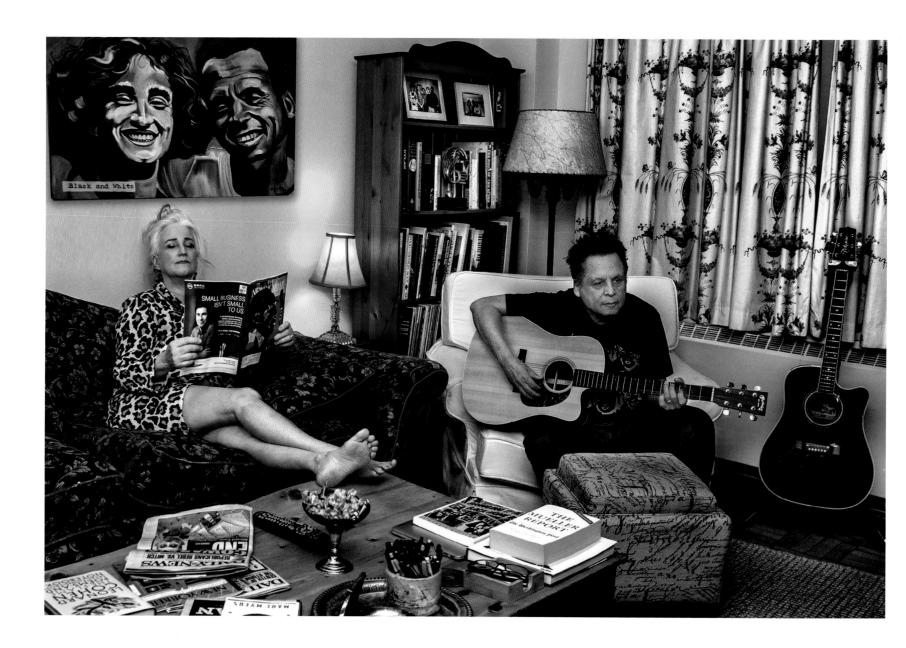

CLAIRE AND GARLAND JEFFREYS

Photographed at their home in the East Village on March 26, 2019.

Claire was born in Paterson, New Jersey, in 1957. She was the youngest of two girls for Dorothy and Leslie. Mom was a secretary and Dad was a computer programmer. Claire won poetry contests at school and wanted to be a writer when she grew up. She read Dostoyevsky's *The Brothers Karamazov* when she was 12 and studied classical guitar when she was in high school. In 1980, after three years of college, Claire moved to Manhattan. She worked as a waitress and at a design firm. In 1989 she met Garland and seven years later they married. They had a daughter in 1996 and named her Savannah.

Garland was born in 1943 in Sheepshead Bay, Brooklyn. He was the oldest of three kids and was raised up by his mom Carmen and his stepdad Ray. Mom was from Brooklyn and Ray was from Harlem. Mom worked at the Domino Sugar Factory and Ray worked as a pullman porter and then as a waiter at Lundy's. Garland spent his childhood in Sheepshead Bay and at Coney Island. He wanted to be a singer when he grew up. He had a good memory when he was little, and he ran numbers for his grandfather. In 1961 Garland moved away to study art history at college. Four years later, with his college degree, he moved back to New York City to make music, working odd jobs along the way. He worked as a waiter, sold posters for Peter Max, was a secretary for Swami Satchidananda, and taught reading at Catholic schools. In 1973 he got a record deal with Atlantic Records and hit the road to perform.

Claire and Garland moved into this apartment in 1998.

"When my sister and I were younger, our mother would drive us into Manhattan at least once a year, usually over the Christmas holidays, to see a Broadway show and have a special lunch. Unlike so many of our Jersey counterparts who thought New York City was Sodom incarnate, she loved it and passed that love on to me, always insisting that we look up at the skyscrapers, the gargoyles, and the architectural ornament that served no purpose but to be beautiful. Sometimes, even now, if I'm walking alone I get lost in a kind of reverie. I look up and my affection for the glorious variety of New York City continues to grow."
—Claire

"I've lived in New York my entire life, and though I've considered living somewhere else, like it says in my song—'the New York skyline, it's calling me home tonight'— no other city comes close to New York."
—Garland

LAURIE ANDERSON

Photographed with her dog Will at her West Village home on December 8, 2019.

Laurie was born in 1947 in Glen Ellyn, Illinois. She was the second of eight children for Mary and Arthur. Her mother taught her to love books. Laurie spent her childhood studying violin, reading, and painting in Glen Ellyn. When she was a little girl she wanted to be "70 different things" when she grew up. When she was 12 she had a diving accident and broke her back. She had to spend a long time in the hospital. Laurie left home to attend college in California. She studied biology before shifting her education to art studies. Her first performance piece was a symphony played on car horns. She did another piece, *Duets on Ice*, playing the violin along with a recording, while wearing ice skates with the blades frozen into a block of ice. The performance ended only when the ice had melted away. Laurie worked as an art teacher, a critic for art magazines, illustrated children's books, invented some instruments, made records, wrote books, performed, was an artist in residence at NASA, produced movies, and was on TV. She collaborated on recordings with Lou Reed, who she married in 2008. Laurie and Lou moved into this apartment in 1999. Laurie lives here still.

"I moved to New York City and stayed. I love it and I am still here."
—Laurie

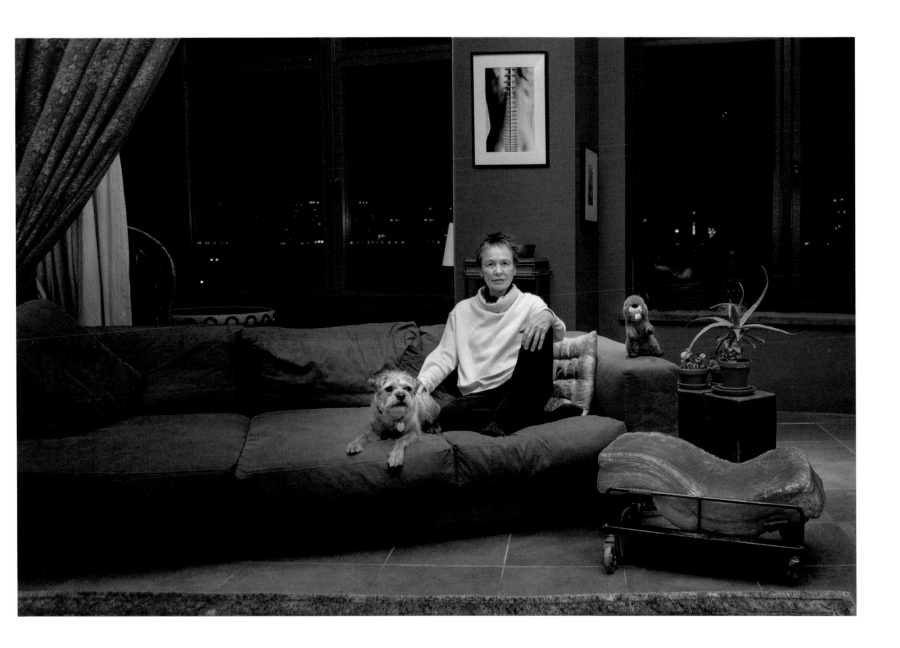

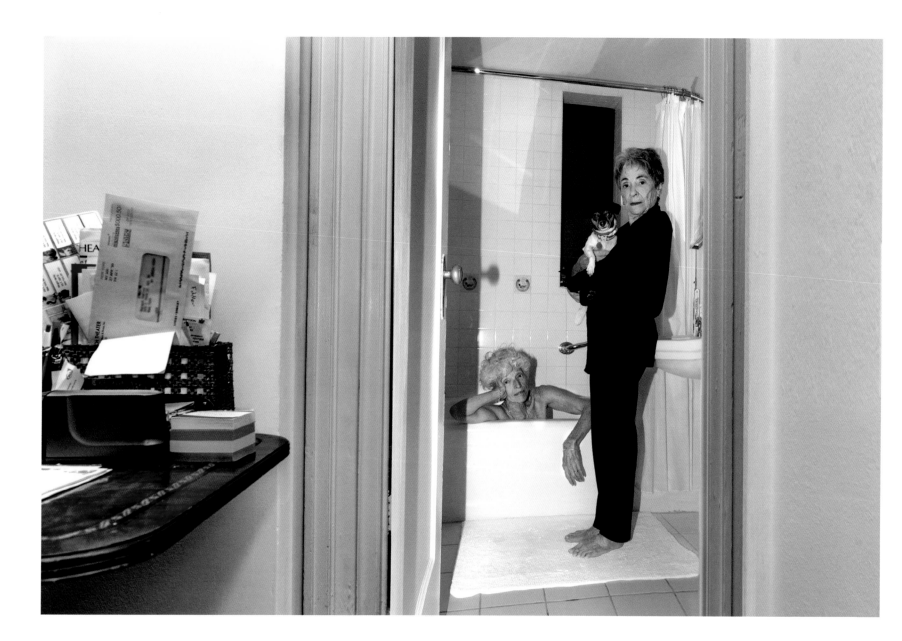

LOIS WALDEN AND MARGOT HARLEY

Photographed at their home on the Upper East Side on May 3, 2019.

Lois Walden was born in 1946 at Lenox Hill Hospital on 77th Street, New York City. Her mother was from New York City and committed suicide in 1973. Her father was from Pennsylvania. He was a superstitious stockbroker who touched a stone every time he walked into the house and turned his pants around a certain amount of times before he stepped into them to get dressed. Lois moved to the Bronx and then grew up in Larchmont, New York, with a sister that she loves very much. She attended Boston University Drama Division. Lois toured the segregated south with Snub Mosley and his all-black band. Snub was a black trombonist. Lois sang at Woodstock '94 in front of 250,000 people, worked at Henri Bendel for three weeks, was a songwriter, recorded three albums, wrote four books and an opera, *Mila*. Lois lived in LA a few brief times, working in the TV business, but hated LA and came back to Manhattan. She was hit by a truck five years ago, and does yoga, meditates, and swims every day.

Margot Harley was born in 1935 at Lenox Hill Hospital, the daughter of a London-born mother and an Ohio-born father. Her mother lived to be 92 and died in the apartment that Margot grew up in on Manhattan's Upper East Side. Her father was in the sporting goods business and brought badminton to America. Aside from one year in London, England, on a Fulbright, and a couple of years in California, she has lived in Manhattan her entire life. She started dancing at seven at the School of American Ballet and was a professional dancer through her young 20s. Margot attended Sarah Lawrence College. In 1968 she went to work for John Houseman, starting the Drama Division at The Juilliard School. In 1972 Margot founded The Acting Company, which she continues to run 47 years later. Margot has lived in this Upper East Side building for 55 years.

Lois moved in with Margot Harley in 1986 and they got married on June 6, 2015.

"New York is an important part of my life that I resist and then I surrender to its energetic pull. I hate the noise. I hate the pollution, but I love the dance, music, and theater, and I love my friends and family who are New Yorkers through and through. I prefer creating when I am in the country, but I like editing in New York. New York is cruel and unforgiving. Nature nourishes me. New York challenges me. Depending on my energy, I can handle the challenge, or not. It is a love-hate thing between us."
—Lois

"I was born in Manhattan and have lived within the same 12 blocks for 83 years. It has changed a lot... mostly not for the better, but I can't imagine living anywhere else."
—Margot

MICHAEL MUSTO

Photographed at his home in midtown Manhattan on October 15, 2019.

Michael was born in New York City in 1955. He was the only child for Ciro and Anna. Dad was a jack of all trades and Mom was the best homemaker and cook in the entire world. They were both first-generation Americans. Michael was born in Little Italy and grew up in Bensonhurst, Brooklyn. He was an excellent student, bringing home great report cards and participating in a host of activities. One day in elementary school, he was chosen to be the lead dancer in a Greek line dance. He wore a dazzling robe that was almost like drag and it was a big hit. He realized then that maybe he could really sparkle someday. Michael went to college and, in the late '70s, moved to Manhattan. He worked some office jobs and delivered rubber stamps on a bicycle. He wrote a nightlife column for New York City's *Village Voice* for 29 years that was read religiously by New Yorkers. He has been on TV and has written four books. Michael moved into this apartment in 2008 and lives there still.

"I can't imagine living anywhere other than New York City, mainly because I can't drive. But here I can get around on my bike and, despite some of the unfortunate changes in Manhattan, I am still privy to great culture, people, and neighborhoods."
—Michael

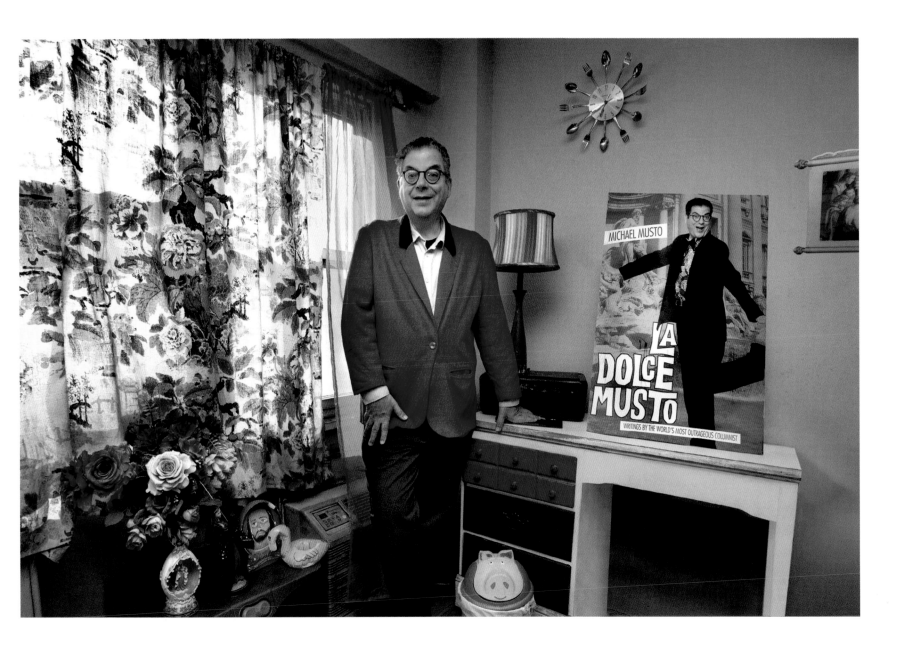

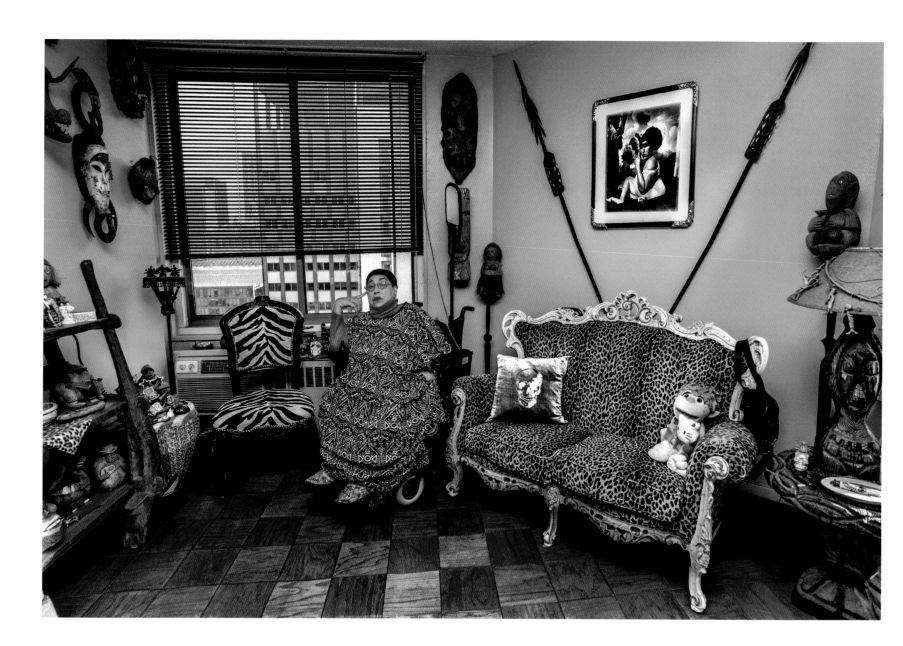

JACQUIE TELLALIAN

Photographed at her home in downtown Manhattan on November 21, 2019.

Jacquie was born in 1953 in Miami, Florida. She was the second of four kids for Jack and Barbara. Mom was mostly a homemaker, and Dad was a graphic designer and armchair philosopher. She wanted to be all sorts of things when she grew up: an astronomer; a comedy writer; a member of the Weather Underground; the great American novelist; Weegee; a shrink; a record producer; and a paint color namer. Jacquie was an excellent reader and writer from a young age, but life in elementary school was a blur of special ed, doctor appointments, physical therapy, and not much else. She did get tossed from the Girl Scouts, though, for being loud, opinionated, and unwilling to be compliant. By 1968, high school was the height of hippiedom and she was right on track: great concerts, the best trippy drugs, wacky friends, and protest marches against war and anything else she could march against. Jacquie ran with a small arty pack, dressed outrageously, and had plenty of adventures wherever she went. She loved the arts, rock 'n' roll, and Broadway show tunes, and excelled at being an attention-getting, flamboyant teenager in a wheelchair, that shot Super 8 films with psychedelic themes. Jacquie left Florida and moved to Manhattan in 1976, ultimately graduating from college with a degree in cinema studies. She wanted to study film, but "the film school said no because she was in a wheelchair." Lots of jobs followed. She was a press release writer at NYU, an assistant to a talent agent, an assistant to a hair and makeup rep, and she also started her own company managing actors. Jacquie made Super 8 films, sold various mind-altering substances, and worked from home as a phone-sex "fantasy" girl. Jacquie retired in 2008 when the economy crashed. She has lived in this apartment complex since 1977.

"I love New York City because it's constantly evolving/de-evolving. You step out the door, hit the streets and you never know what you're going to see or who you're going to meet. New, weird adventures lurk in every corner—even with the gentrification that has bro-ified the city. This town always challenges you—which, of course, can also suck the living life out of you—but it keeps your mind clicking. I fantasize about living elsewhere, somewhere less insane, or with better weather, but when I visit those places, like LA or New Orleans, I can't get back to NYC quick enough! Look, it ain't Oz here, and yes, it's turned into Blandtown with too many richies, no gritty Times Square smut palaces or tacky streetwalkers, but there's still plenty of edge left—you've just got to dig a little deeper to find it. I'm cool with it all."
—Jacquie

CARLOS "LOS" FRANCO

Photographed with his dog Banquo at his home in the East Village on October 28, 2019.

Carlos was born on the Lower East Side in 1986. He was the last of three kids for Rosa and Carlo Sr. Mom was a homemaker and Dad worked in sales for a plastic company. Both parents hailed from Ponce, Puerto Rico, and all three kids were first generation here. Carlos grew up on the Lower East Side. He was an exceptional basketball player and as a kid was way, way into music. He wanted to be a rapper when he grew up and worked at a local mixed tape store where new local hip hop could always be found. He also worked as a "bike messenger," in retail, and in the restaurant biz. He attended college and studied audio engineering and business. In 2015 Carlos and Scarr Pimental opened a pizza restaurant on the Lower East Side in the art gallery district. He moved into this apartment with his family in 2000 and they live there still.

"Growing up in New York was never easy. We grew up with nothing, still don't have much. The thing that has always kept me going is my community—a community that wasn't built alone. It's a community we built and one we stand for. When things get discouraging or frustrating, especially in the "New" New York that lacks diversity, our community, my streets, my local spots, my people, the ones who are just like me are the things that keep me going. That is what I fall in love with every time, still to this day. I am a New Yorker, I am a Puerto Rican. I am a business owner, a son, a friend, a lover—but first and always, I am a New Yorker. Being a New Yorker is special and has always given me drive. Drive is what this city has taught me."
—Carlos

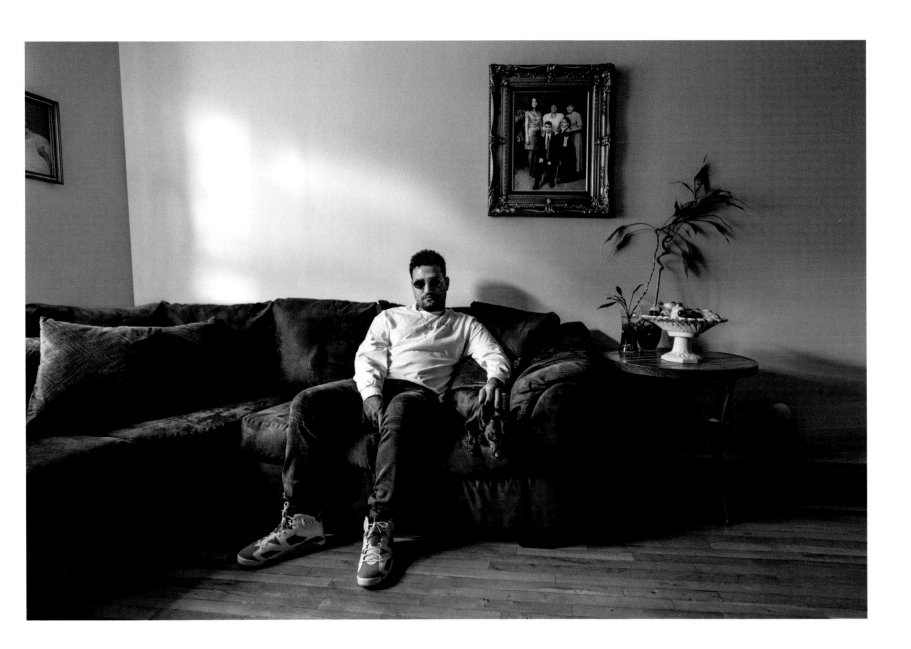

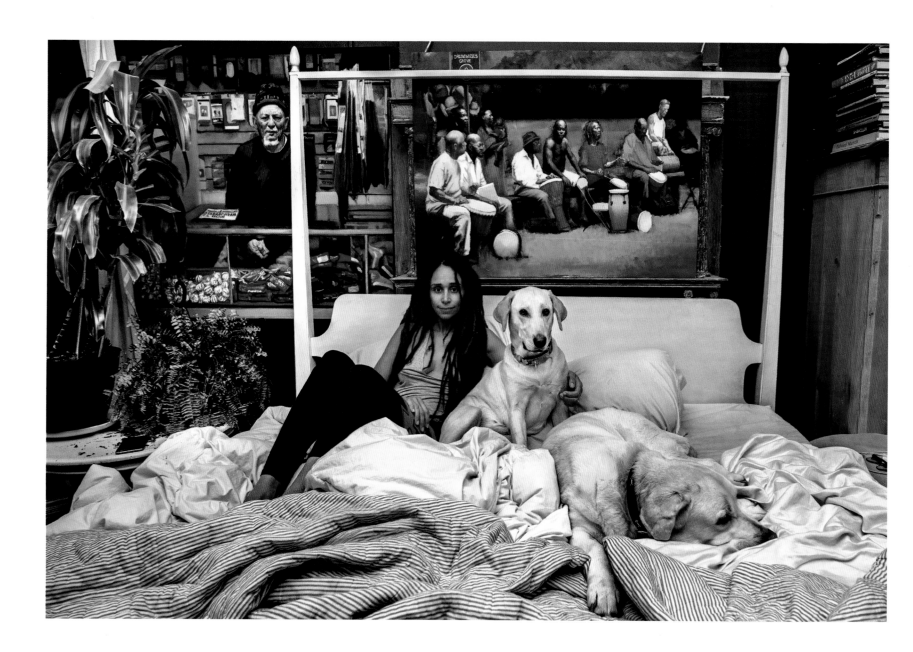

SYLVIA PARKER MAIER

Photographed with her dogs Milo and Boney at her home in Brooklyn on October 11, 2019.

Sylvia was born in New York City in 1969. She was the only child for Maria and David Parker. Dad wrote songs for Motown and Mom was an Upper East Side madam, and also a classical pianist. Mom and Dad split up a few years later. Sylvia spent her childhood attending private school, studying voice and musical theater. Most summers were spent in Argentina with her mom's family, where she went to church with her gramma every single day, falling in love with the religious paintings. By the time she finished high school she had her heart set on being a painter, attending the Art Students League, the National Academy of Design, and the New York Academy of Art. Sylvia worked as an usher at the Met, as a waitress who got fired often, and also did some modeling. In 1997 she met Andre, and in 1999 they got married and moved to Brooklyn. In 2004 they bought this brownstone and live there still with their two sons, Rio and Noah. Sylvia is an award-winning painter; her work is in movies and she shows in New York galleries.

"My mom was asked, 'Where are you from?' all the time because of her thick Argentine accent. She'd respond, 'I'm a New Yorker,' even though she wasn't born here. If she was a city she would have been New York. When I miss her, I look at the skyline and feel her. It's a vibe. I was born here. I travel a lot but I am firmly a New Yorker."
—Sylvia

CHARLIE ROMANOFSKY

Photographed at his apartment in the East Village on July 15, 2015.

Charlie was born on December 27, 1957 in the Bronx, New York, the first of two sons to Sydelle and Sidney Romanofsky. Mom was a housewife and Dad was a tool and die maker. The family moved to Queens Ravenswood housing project in 1961 and then to Coney Island Projects in 1969. While he was in high school, he worked selling cotton candy at a stand at Coney Island and went to the beach there most days. Charlie was really smart. Skipping classes often in high school, he still graduated number one in his class. Charlie did a little traveling after high school but always ended up back in Brooklyn. He worked for the government as a real estate specialist. In 1995 he moved to East 5th Street in the East Village and took a second job as doorman for a weekly transvestite event. Finally, Charlie quit both those jobs and started a very successful dog walking service. Charlie died on July 17, 2015, two days after I took this photograph.

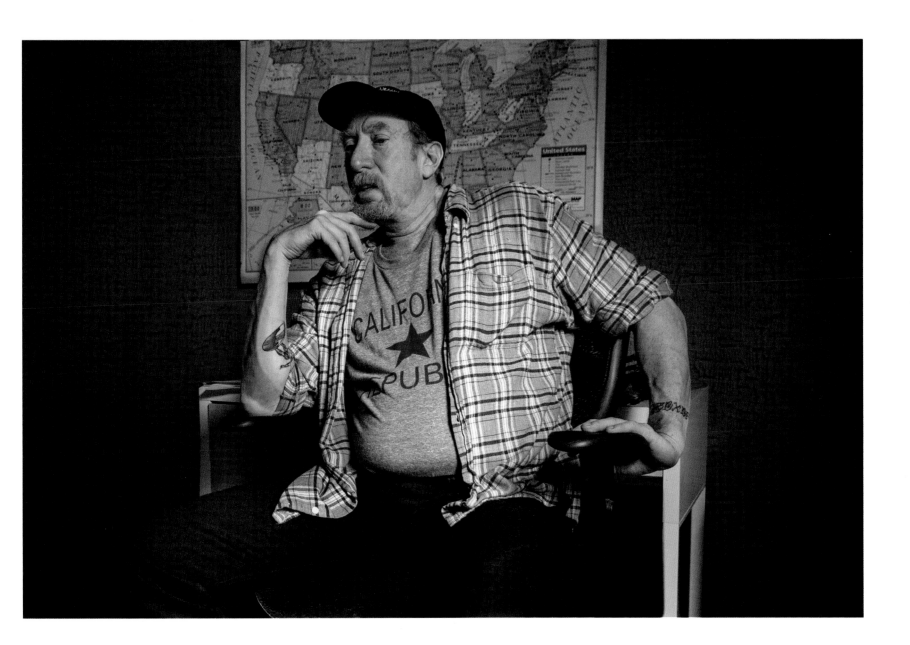

KAROL JACKOWSKI

Photographed at her home on the Lower East Side on March 27, 2019.

Karol Jackowski was born in 1946 in East Chicago, Indiana, one of five kids for Shirl and Henry. Shirl and Henry owned and ran the family business, the "Normal Bakery." Hank did the baking and Shirl managed the shop. Karol spent her childhood growing up in East Chicago, going to school and working often at the bakery. Her brothers scrubbed the pots and pans, and her and her sisters frosted the donuts and sprinkled the cupcakes. Karol read the book *Eloise* when she was little and decided she too wanted to live in New York City when she grew up. In 1964 Karol graduated high school and moved to South Bend, Indiana, joining the Sisters of the Holy Cross and becoming a nun. She stayed there for 15 years and worked as an administrator at Saint Mary's College. For the next seven years Karol spent her time back and forth between New York City, studying for her PhD and as a dean at Saint Mary's College. Finally, in 1990, she packed her things and moved permanently to New York to become a writer. She lived first in the West Village and then in the East Village, where she has lived ever since. Karol worked in a gift shop, as a file clerk, wrote books, tutored children, and made religious folk art paintings. She has published nine books and is currently a college professor, teaching creative writing. In 2003 Karol was forced out of her East 13th Street apartment because of unaffordable rent increases. She moved to a rent-controlled apartment on the Lower East Side and lives there still.

"I'm quite sure I've had at least one past life in New York City because I feel more at home here than anywhere else I've been. I love that eight million of us from all over the world live in five little miles and we get along just fine. I thrive on intense diversity and the experiences we have as a result. It's the place to be if you want to make art because art is everywhere in New York City. Every day I can walk out the door and find a story to tell. As a writer, and as a nun, New York City (and all its hellish features) is my heaven on earth."
—Karol

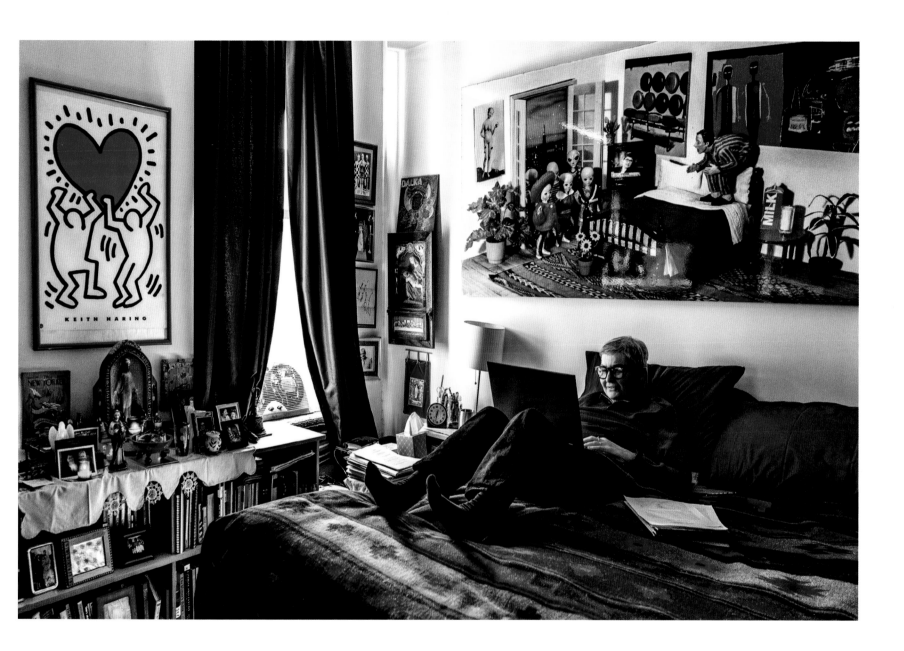

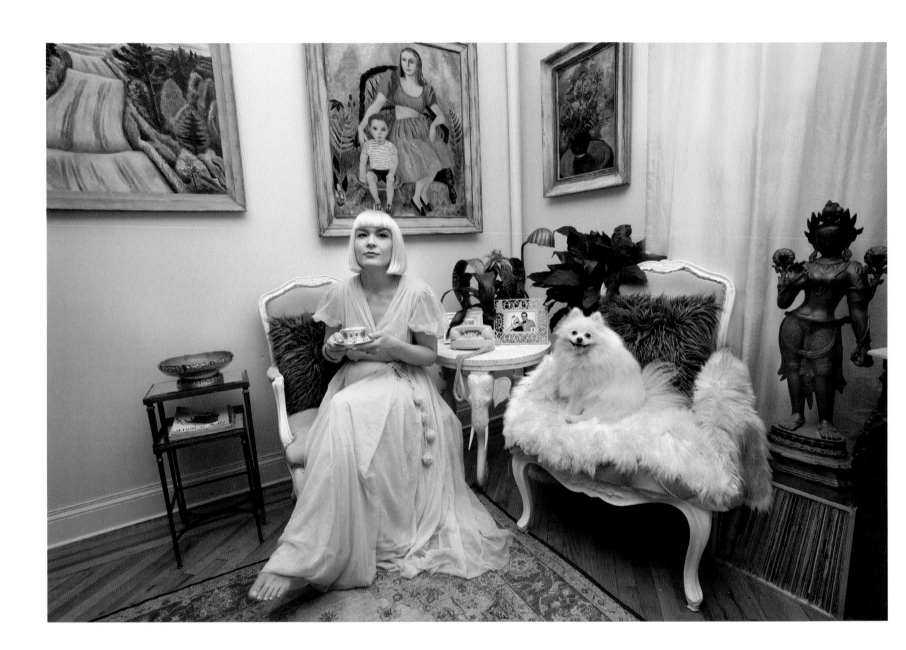

MARINA PRESS GRANGER

Photographed with her dog Odette at her home in the East Village on August 19, 2019.

Marina was born in 1984 in Kiev, Ukraine. She was the only child for Lilly and was raised by her mother's parents Serafima and Vladimir. Grampa served in World War II and was an oral surgeon. Gramma taught Russian literature and Mom was a biologist. Gramma and Mom took Marinato lots of museums in the Ukraine and St. Petersburg when she was little. In 1991, as the Soviet Union was crumbling, they moved to Midland, Brooklyn, in search of a better life. Grampa washed dishes to support everyone when they got here. Marina attended the same elementary school as Ruth Bader Ginsburg. She studied ballet for ten years, but wanted to be a shrink or an art curator when she grew up. She got a degree in art history at college and has been working in the New York City art business ever since. She left Brooklyn for Manhattan in 2011. Marina got married to Andrew Granger and they moved into this apartment together, where they live still.

"When I was struggling and just out of college, I helped an elderly woman cross Delancey Street at Bowery. She asked me if I lived in the neighborhood and I said, 'Oh no, I can't afford to.' She looked at me and said, 'If you belong here you'll find a place here.' That was a game changer for me. Well, I belong here and I did find a place. I can maybe get a second home somewhere else, but I could never move away from NYC. My most broke friends who grew up here are managing and finding a place to thrive here also. The bazillionaires can buy up all the real estate in Midtown all they want. No one wants to live there anyway!"
—Marina

SAM SWOPE

Photographed with Jim Tryforos at his home on Manhattan's Upper West Side on September 18, 2019.

Sam was born in 1954 in Gettysburg, Pennsylvania. He was the fourth of five kids for Mary and Donald. Mom was a housewife and a photographer, and Dad was a lawyer. Sam spent his childhood in small-town Gettysburg, where his dad's family has lived since 1802. He was a smart kid who did well at school, but not so good at sports. When he was little, he wanted to be Chief Justice of the Supreme Court. After several years at college, Sam moved to New York City in '78 to stay. Sam worked as a cater waiter, at a bookstore, as a prop man in the movie business, as a writer of books for adults and kids, and at the library on Fifth Avenue, until he finally founded the Academy for Teachers.

JIM TRYFOROS

Photographed with Sam Swope at his home, downstairs from Sam's apartment, on September 18, 2019.

Jim was born in San Jose, California in 1956. He was the oldest of three kids for Jim and Olga. Dad operated car washes and Mom was a beautician. Jim spent his childhood in California. He took piano lessons seriously in high school and sang in all the choruses, doing everything perfectly well, to the point of being a worry for his parents. He mowed lawns, babysat, was a lifeguard, was a waiter, and a landscaper. In 1994 he moved to New York City on a scholarship to the Martha Graham School for Dance. After that he toured worldwide with the Nikolais Dance Theater before graduating from NYU in physical therapy in 1998.

Sam and Jim met in 1992. In 1994 they needed an apartment. One day they were walking down 90th Street and Jim noticed two empty floors in a brownstone. They walked up the steps and rang all the bells until someone answered. It was the landlady. She'd just renovated two studio apartments, one on top of the other. They took both and have lived upstairs/downstairs but separately ever since.

"I like New York's variety, the way the city has so many different kinds of people doing such different kinds of things."
—Sam

"New York City—in your face and edgy. Well, not so much any more. Lost are the good old days of grungy neighborhoods, sex-filled shadows, and the energy of the unexpected. In this age of Uber, big-box stores, and online shopping, the unusual, the unique, and the adventure of discovery seem lost forever to high-end everything, the Starbuck's mentality, and smartphone addiction. Thankfully, there are still crowds to get lost in, but they seem more homogenous than ever and now even being gay is normal. No less sinful—gay people are holding hands in public, kissing in broad daylight, and even getting married. Soon, if pot becomes legal, all vice will be struck down and the NYC underbelly will be tragically exposed. Yet, here I remain in the city that never sleeps, stuck in this cliché. Where possibly else to go? On some levels, the city still speaks to me. It offers the refuge of anonymity and, after all, it has been my home for so many years. And how possibly to live without its brilliant and cherished public transportation system and the community of the few New Yorkers who still seem to understand the city, who appreciate and respect it, and who also love it?"
—Jim

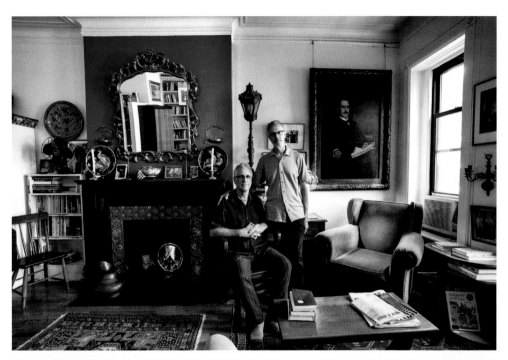

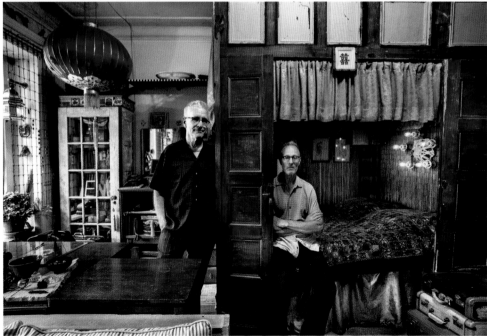

LINDA SIMPSON

Photographed at home in Times Square on November 8, 2019.

Linda was born Leslie John Simpson during the swinging '60s in Gaylord, Minnesota. He was the oldest of three boys for Robert and Mary. Dad was a minister and Mom was a housewife. Leslie spent his childhood years growing up in midwest Minnesota. He was an average kid at school with B grades and no particular aspirations, other than wanting to explore a broader horizon than what Minnesota had to offer. He was on the debate team and wrote for the school newspaper. Heading to New York City for college, he left the Midwest behind. Leslie moved to Manhattan in the '80s and shortly thereafter became a major player in the East Village drag scene. He changed his name to Linda and had her first nightlife show at the famous Pyramid Club. Linda is a game show hostess now at a weekly New York City bingo event and is the author of *The Drag Explosion*, a slideshow of the '80s and '90s New York City drag scene.

"The longer you live in New York City, the more you realize it's always changing. I don't like that New York has become so expensive, including taxi fares, but love the diversity of people, and I think New Yorkers are fascinating."
—Linda

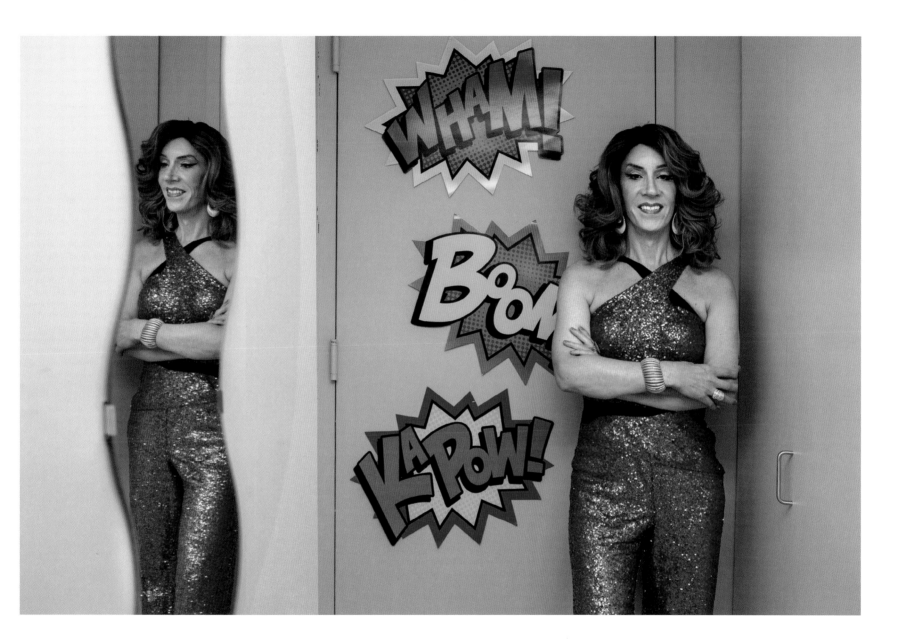

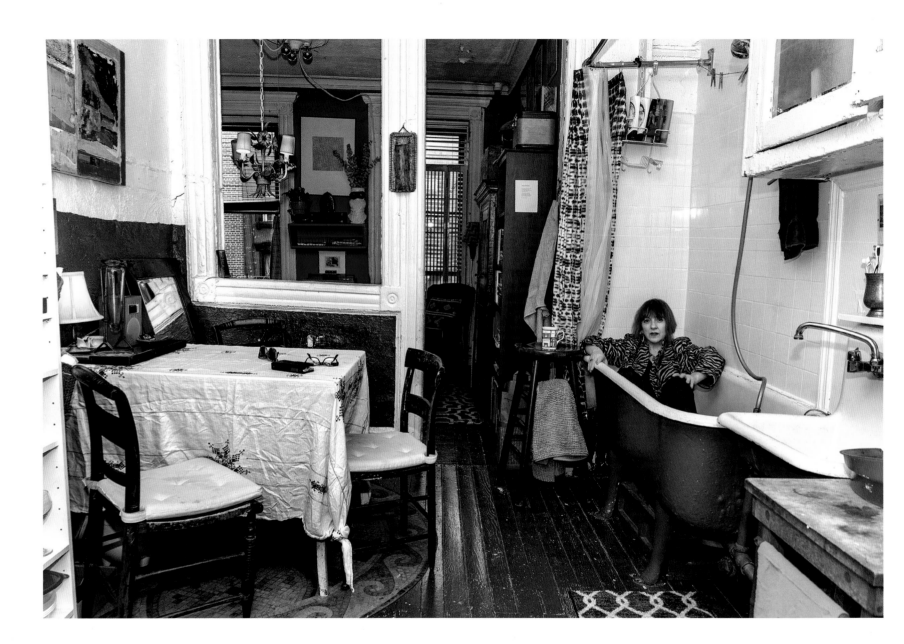

LIZ DUFFY ADAMS

Photographed at her home in the East Village on April 28, 2019.

Liz was born in Newark, New Jersey, in 1957 and grew up in Massachusetts. She was one of four kids for Gail and Quin. Mom was a homemaker and Dad worked in sales for a semi-conductor company. After that, he co-founded Germanium Power Devices. Further up the road, they split up and Gail became a really good potter. Liz spent her childhood growing up in the woods. There was a lot of wild free-roaming in those days with friends and siblings, and a lot of skating in the winter months. She wanted to be an architect when she grew up and made a book when she was eight of her house designs. Liz was a shy and introverted little girl and an obsessive reader. She did well at school but mostly found it horribly boring. She came out of her shell in high school under the influence of sex, drugs, and theater. At 17 she moved to Cambridge, Massachusetts. Working two jobs and saving all her money, she was able to move to New York City to study drama. Graduating in 1980, Liz needed an affordable apartment and she found one in the East Village. She took the first one she could afford and lives there still. For the next 15 years, Liz was an experimental theater artist, a Shakespearean actor, a waitress, a busboy, a hostess, a line cook, a dishwasher, and a maker of pornographic telephone recordings. Then she wrote a play set around the famous 1988 Tompkins Square Park riots. Encouraged by the success of this play, Adams went to the Yale School of Drama to study playwriting. Liz has written countless plays since then, including one that has been produced over 70 times. Liz believes her rent-stabilized apartment in the East Village has made her art life possible.

"I'm grateful I came to the city when it still had a wild heart, when a broke young person could get a cheap apartment in Manhattan and you could make theater for free in raw lofts. It was a time of danger and heartbreak. We lost a lot of beautiful people. But this gentrified century of swollen rents and Disney-fied city life is not good for art, and it's a hell of a lot less fun. Still, I love New York City and its stubborn soul."
—Liz

TOM BIRCHARD

Photographed in his kitchen at the Veselka Ukrainian Diner on January 13, 2020.

Tom was born in 1946 in Williamsport, Pennsylvania. He was the first of two boys for Bob and Sanny. Dad worked for the Campbell Soup Company and Mom was a homemaker. Tom spent his childhood years growing up in Pennsauken, New Jersey. He was a shy and withdrawn kid. He didn't know what he wanted to be when he grew up, and still doesn't know. He wasn't really athletic, and didn't participate in many extracurricular activities, but when he was 16 he got a job at the local A&P supermarket and realized he loved cooking and the food business. He left home for college in 1964. There, he met his first wife Marta. She was a beautiful Ukrainian girl whose family owned a candy store called Veselka on the Lower East Side. They got married and had two sons, while Tom worked at Veselka and studied business at college. Eventually he and Marta divorced, and the neighborhood took a bad turn. Veselka struggled and almost went out of business, but Tom continued to manage the place through it all, eventually purchasing the restaurant outright. Somewhere around 1996 the *Village Voice* gave them a great review and that changed everything; Tom did a major expansion to make room for the success that was heading his way. In 1982 Tom met and fell in love with Sally, a neighborhood veterinarian. Thirty-eight years later, Tom and Sally are still going strong, and the last time he checked he had five kids and four grandkids. Veselka remains a landmark East Village restaurant that is on every tourist and local's go-to list for 24-hour food. Tom travels, cooks, cycles, and holds court at the diner.

"I have lived and worked in the East Village all of my adult life. I feel extremely fortunate that I have had the opportunity to be part of this extraordinary community. I felt at home here from day one, and have had the pleasure of meeting a lot of interesting and creative people. I am concerned about the escalating pace of development in the East Village. Much of what I loved is disappearing but there is still a lot left here to love. I am on the board of Village Preservation, an organization that works to preserve the architecture and culture of the East and West Villages. I am thankful for my wife Sally and our love for each other—it has never wavered; for my five children, who have all matured into good people; for my four beautiful grandchildren; for friends and fellow East Villagers; and for so many wonderful pets, past and present."
—Tom

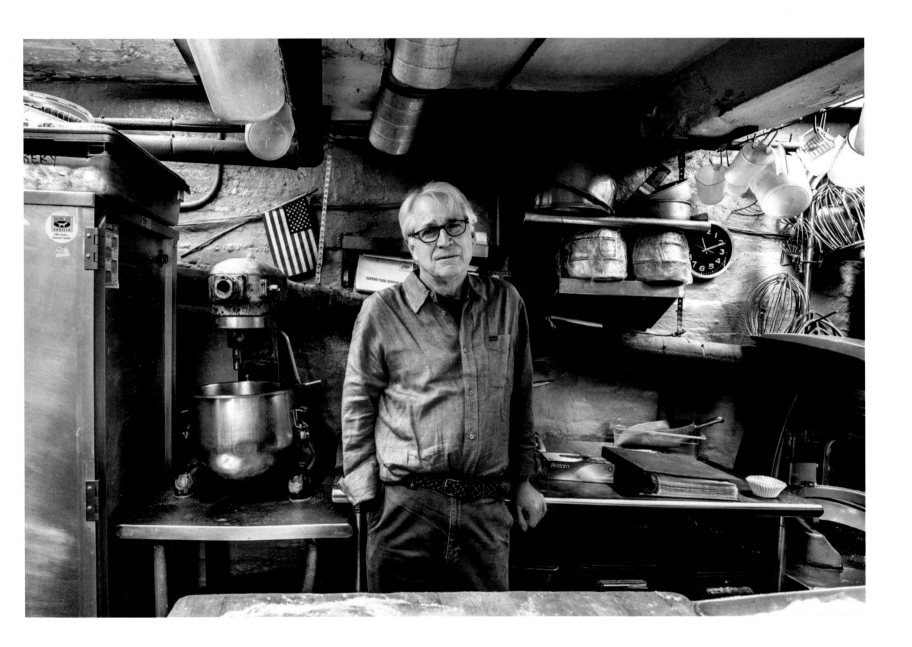

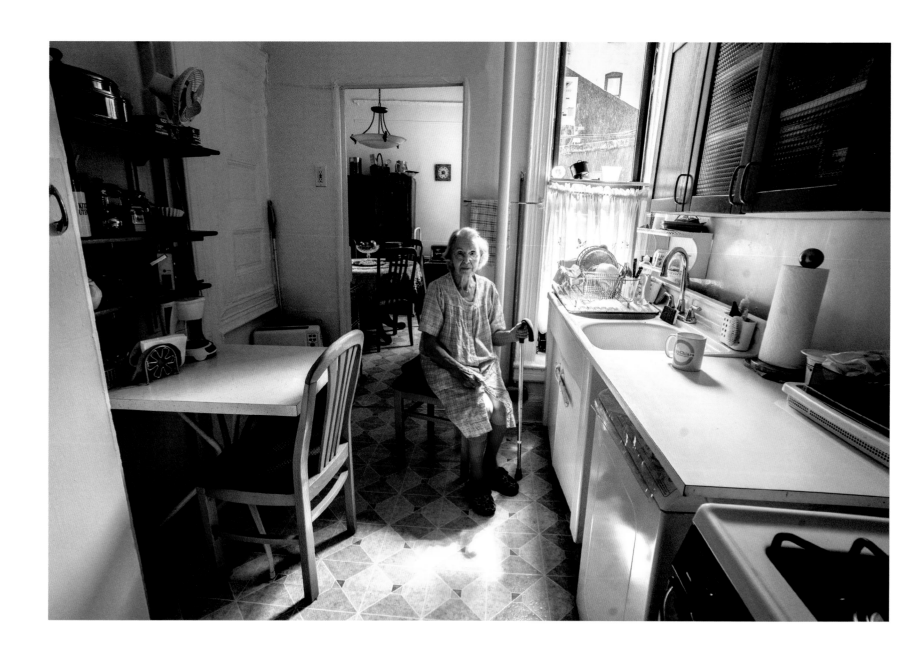

THERESA BUCHICCHIO

Photographed at her home in the East Village on June 28, 2019.

Theresa was born in New York City in 1923, the oldest of three girls for Mariana and Michael. Mom was a mom and Dad was an iron worker. He made fancy gates with his brother on Spring Street. They started splitting up when the girls were little. Theresa went to the same Catholic school that she sent her own children to. The nuns were really mean, physically abusing her and often locking her in the closet. She was really good at math. In 1940 she worked in a sewing factory for good pay. The sisters would hand the checks over to Mom and she would buy bonds. Theresa married Michael in 1944 and stayed married to him for 53 years. She had a job candling eggs. Michael was in the army. After the army, Michael worked at a sewing factory, then they owned a gay bar called McCanns at 74 3rd Avenue for ten years. They lived above that bar in a cold water flat, with their two kids. In 1960, when the cops were shutting down the gay bars, they moved into this apartment on Stuyvesant Street for $84 a month, where Theresa still lives. In 1977, when Theresa was 50, she went back to college for two years and got a diploma. She worked until she was 80 years old.

"I love everything about New York City. I can go downstairs anytime and everything is around. You can go to a show. I like New York. I love New York. I never wanted to move and my husband never wanted to move. Everything is at your fingertips."
—Theresa

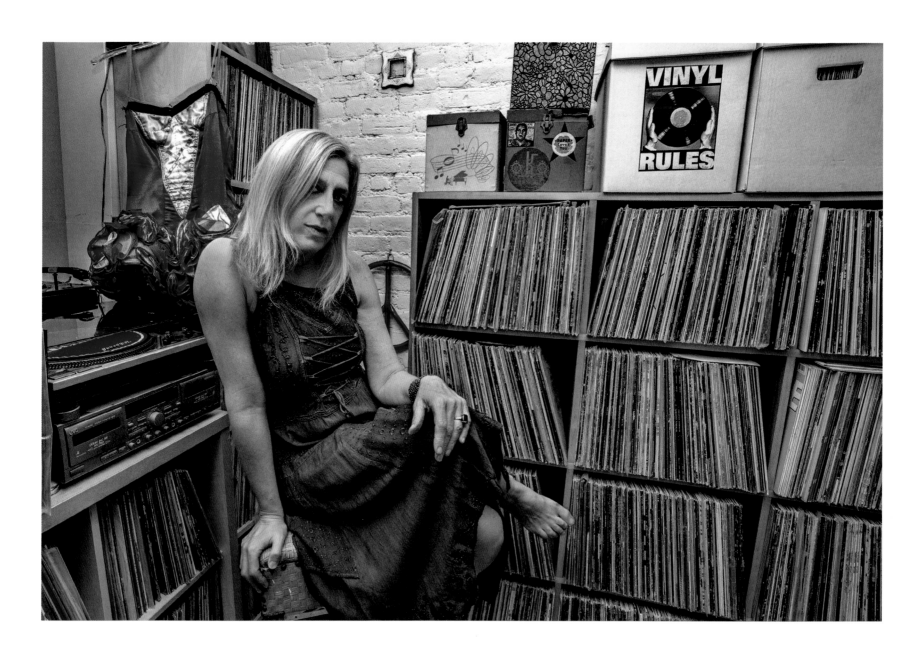

DELPHINE BLUE

Photographed at her home in the East Village, with her vintage Rockettes corset, on June 30, 2019.

Delphine was born in 1957 in Queens, New York, the youngest of four kids and the only girl to Anita and Sol. Mom and Dad were both from New York. Mom did volunteer work and Dad owned a hardware store on Avenue C in the East Village. Delphine really liked the family's cleaning lady when she was little, and for a long time wanted to be a cleaning lady when she grew up. Later she changed her mind and wanted to be a ballerina, and was a dance major in college. She worked in the puppy room at the Animal Rescue and as a traffic reporter. Then, at age 21, she moved to Manhattan for good and started DJ'ing. She worked at the really good places—the Ritz, Danceteria, Peppermint Lounge, the Palladium, the Underground, and the Roxy—then started doing radio shows. She does voice-overs and curates music for events. She has lived in this apartment for 22 years.

"I grew up in a 'two-fare neighborhood.' It took a bus and a subway to get to 'the city.' There were no transfers between bus and subway then. I'm pretty experienced with the 'going into the city' thing, so the allure of 'the new Brooklyn' isn't there for me. I don't want to live in another borough. Like they say in West Side Story, *I like the island Manhattan. Smoke on your pipe and put that in."*
—Delphine

PAMELA LUBELL

Photographed at her home on the Upper West Side on July 1, 2019.

Pam was born in Brooklyn in 1964, one of two girls for Frederick and Phyllis. They were from Brooklyn, too. Fred was a podiatrist and Mom sold real estate. Pam grew up on the south shore of Long Island in a suburban beach town. She wanted to be a fashion designer when she grew up, and spent her teenage years in a pair of high-heeled Candies and shoulder pads. Pamela's high school was right across the street from her house. Every morning she got in her mother's blue Caddy and drove 150 feet to school. Pam studied film at college during the day and went to the Palladium and Area at night, moving to Manhattan's West Village as soon as she graduated. She worked at a video store at night and at an ad agency during the day. She worked for Harvey Weinstein for ten years, too. She got married and divorced and has two daughters, Sage and Piper. She is a film producer, loves music, and collects street art. Pam has lived in this apartment for 20 years.

"I got married and divorced, but my love for New York City is forever... until death does its part."
—Pamela

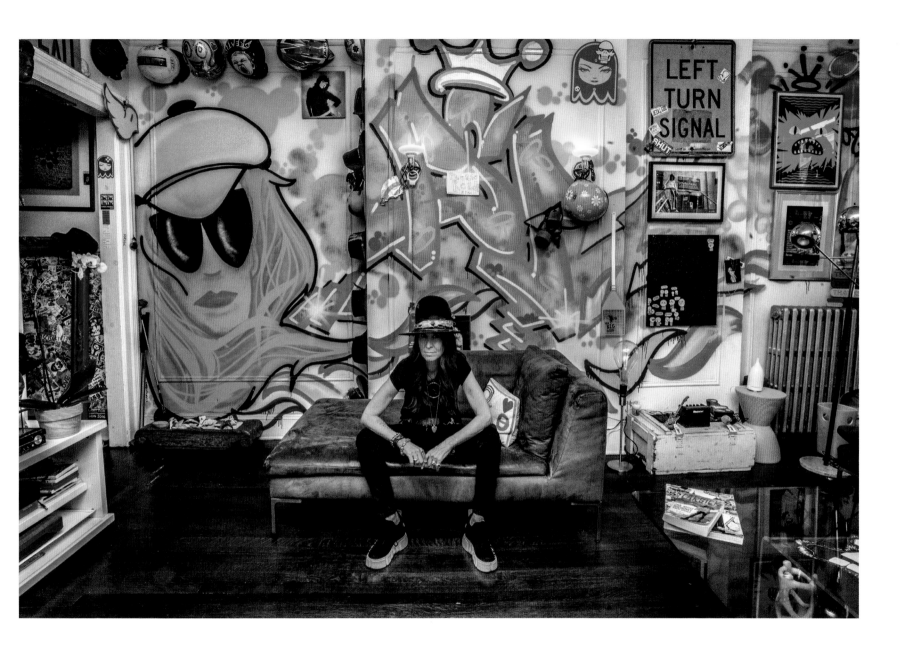

MITCHEL BAYER AND BEA WINKLER BAYER

Photographed at their home on the Upper West Side on December 11, 2019.

Mitchel was born in 1931 in Manhattan, New York. He was the youngest of three kids for Saul and Estelle. Dad was a real estate broker and Mom was a homemaker. Mitchel spent his childhood on Manhattan's Upper West Side. He wanted to be a symphony conductor when he grew up. He conducted an orchestra at school once and still has the baton to this day. Mitchel worked as a delivery boy for the local butcher when he was ten years old, and when he was 14 he worked at his uncle's department store, Arnold Constable & Co, which served the rich and elite in New York City. Mitchel also bought his first painting when he was 14 and has continued collecting art throughout his life. He excelled at everything, graduating from high school in a short two-and-a-half years, and went off at only 16 to Wharton Business School. "Four years at Wharton was $600 back then and my MBA cost me $480." Mitchel was drafted into the Korean War. He was sent to an army base in Georgia and became the chief financial officer of the US Army Hospital there. Two years later, he finished his army time and continued his education. Mitchel worked in finance his entire career.

Bea was born in 1941 in New York City. She was the first of two kids for Harry and Else Winkler, and a big sister for Henry Winkler. Dad was in the lumber business in Germany until he and his wife left to escape the Nazis, ending up finally in New York City. Bea grew up on the Upper West Side of Manhattan and summered on Lake Mahopac. She wanted to be an ice skater when she grew up, even studied teaching at Russell Sage College because they had an ice skating rink. Bea worked as a children's clothing buyer at May Co Department Store and also taught nursery school.

Mitchel and Bea met in 1969 outside the Metropolitan Opera in a snowstorm, and married the same year. They have three daughters and moved into this apartment in 1972.

"We are true New Yorkers. I love the environment it offers us: Central Park, Riverside Park, the museums and concert halls, and the joy of walking the streets. It's a great walking city."
—Mitchel

"New York is a beautiful city. I was born here and I never left. I love that everything is so accessible and, as my husband said, we are true New Yorkers. I love the museums and the parks. It is a great walking city."
—Bea

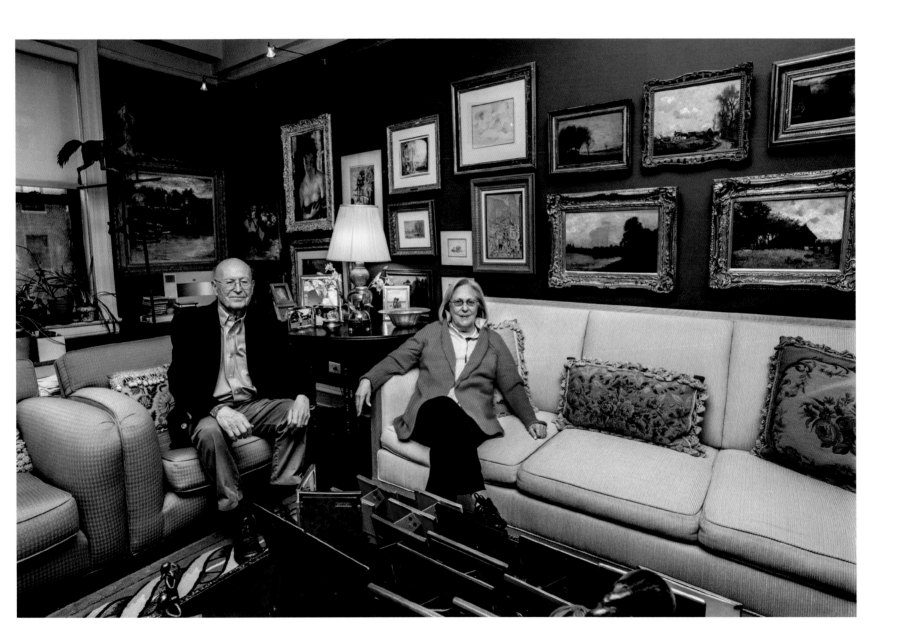

VICKY ROMAN

Photographed at her apartment in the East Village on April 13, 2019.

Vicky Roman was born in San Juan, Puerto Rico, in 1945. Her parents were Martina and Alberto, but she was adopted and raised up by Providencia and Emilio. They had a daughter who had passed away, so Vicky was their only child. Emilio was a "good guy" and Vicky loved him a lot. When Vicky was seven, they moved to New York City's Lower East Side, where she's remained her entire life. Vicky was an OK student. She wanted to be a tap dancer when she grew up. Vicky left home in her 20s and got an apartment on the Lower East Side. She worked at a picture frame factory, a sewing factory, a factory that made decorative pins, and, later on, a printing press. She moved into this apartment in the East Village in 1972. She lives with her friend Anna and her dog Sparky. Vicky collects fridge magnets.

"I moved to this neighborhood in 1952 and I have never lived anywhere else. I love it here. I love the mix of people here. I like having so many people around. I talk to everybody, but it's changed a lot. The noise bothers me now and I miss all the people I used to know that lived around here. They had to move because the rent got too high. If I won the lottery I would just get a nicer place around here, somewhere in the East Village, but I would still keep this one because I would miss it."
—Vicky

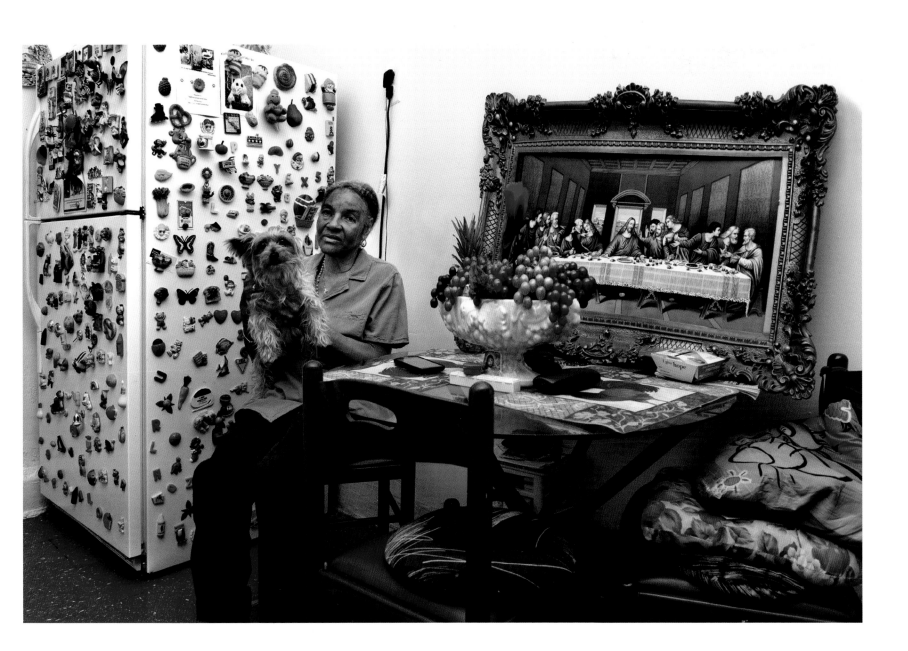

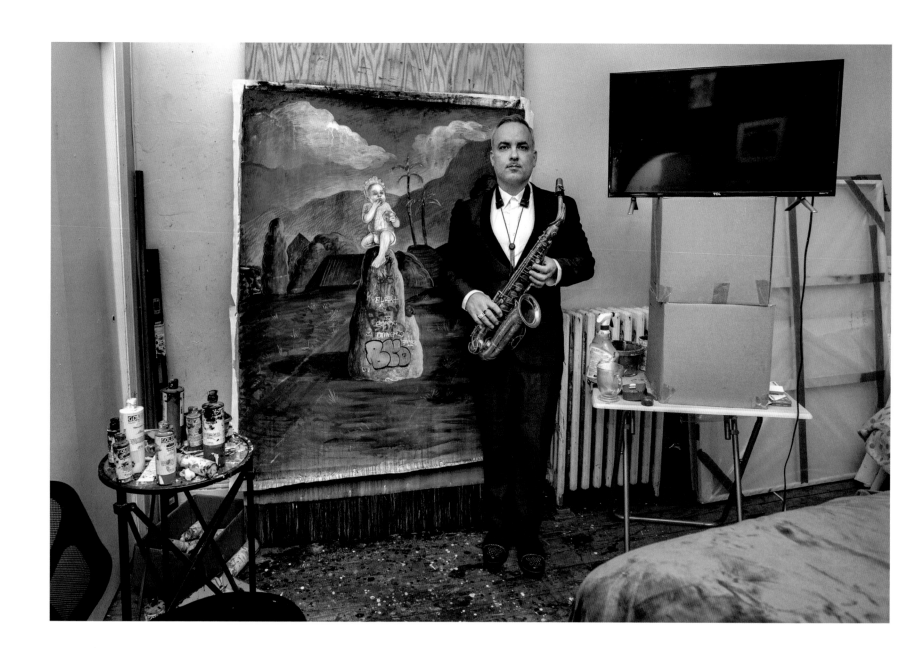

NOAH BECKER

Photographed at his home in Brooklyn on December 17, 2019.

Noah was born in 1970 in Cleveland, Ohio. He was the youngest of two boys for Florence and David. Mom and Dad ran an art supply store. When Noah was two, the family moved to British Columbia, Canada. He grew up on Thetis Island and Victoria. He went to school for three years and then was homeschooled after that. When he wasn't at home doing homework, he was painting or playing the sax. Lacking the social skills kids pick up at school, Noah was often in trouble for fighting. He wanted to be a famous jazz musician, or a famous electric guitarist, or a famous artist when he grew up. He studied painting later on at college, and in 1995 moved to Toronto to study saxophone with Pat LaBarbera. In 1997 he moved to Manhattan. He plays sax, makes art, and writes for art magazines. He moved into this Brooklyn apartment in 2010.

"I moved into this neighborhood in 2010—it's a magical neighborhood. I publish Whitehot Magazine, *a popular art magazine, so I'm in the art scene a lot, showing my paintings, meeting artists. I'm also at the jazz clubs a lot (I recently played at the Village Vanguard with David Murray). If you don't constantly hustle, it gets isolating in New York. Other than that, I really love it here. Years ago I saw Mars Bar become a TD Bank—that kinda sucked."*
—Noah

BIJOU CLINGER

Photographed at one of her apartments on the Upper West Side on December 10, 2019.

Bijou was born Eleanore Clinger in 1955 in Sharon, Pennsylvania. She was the oldest of four kids for Julia and William. Mom was a homemaker and Dad was a politician, spending nine years in US Congress. Bijou spent her childhood summers in Chautauqua, New York and wanted to be an actress when she grew up. She was a good student and busy with all kinds of things: drama club, orchestra, Girl Scouts, dance classes, and voice lessons. At 16 she left home for an all-girls boarding school, followed by six years of theater at college. She moved to Manhattan in 1979. Bijou worked as a waitress and cleaned apartments. She married Greg Miller in 1983 and seven years later they moved into this building. They lived with their two daughters in the apartment for a few years and then in 2002, needing more space, they rented an additional apartment in the same building. They set up bedrooms in one apartment and living areas in the other. It was an unusual setup, even by New York's nutty standards. They have all spent the last 18 years running between the two apartments, often in only a towel or pajamas. Bijou is an acting coach for kids auditioning for the performing arts high schools.

"I had a good career, in that I was almost always working. Now in my 60s, I am able to enjoy the city more because I have more time for museums and theater, plus I still do a bit of acting. I love where we live. When we first moved here in 1979, gentrification was just beginning and it was scary. But it was the perfect neighborhood for many other reasons: the museums, the great public schools, the park, the balloons being blown up a block away for the Macy's parade... The things I don't like about New York City have remained constant over the years—the crowds, the traffic, and the lines. Gentrification is awful, but I appreciate how safe I feel living here now and how things are much cleaner and less shabby. Luckily, we have a rent-stabilized apartment or I am sure we would not be here. I am very grateful."
—Bijou

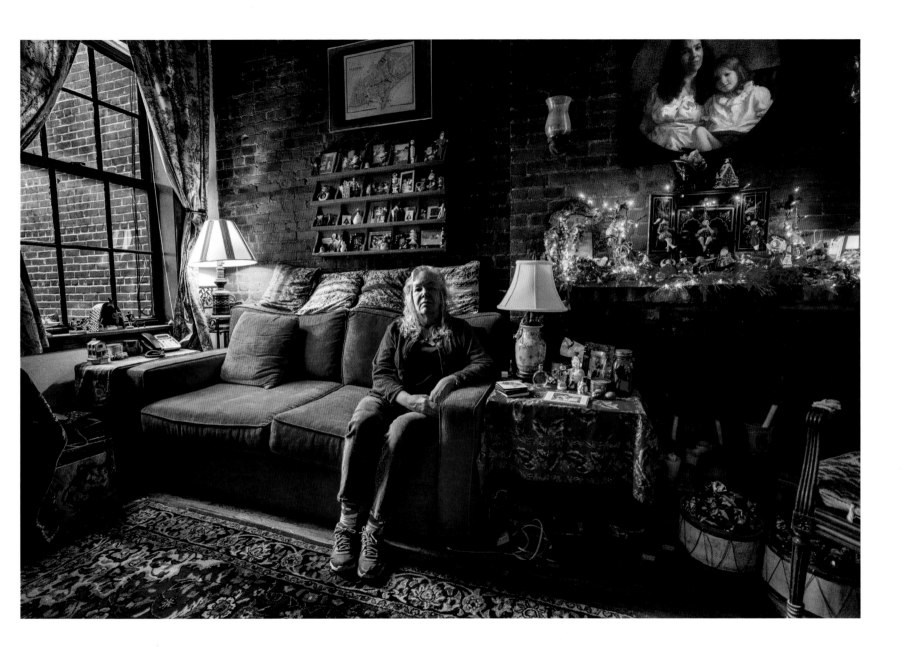

JEN POE

Photographed at her 26th-floor apartment on Manhattan's West Side on June 29, 2019.

Jen was born in 1985 in Queens, New York. She was the third of three kids for Margaret and Donald. Mom was from Barbados and worked as a home health aide, and Dad was from South Carolina. Dad ran a private taxi business before the days of Uber. When Jen was four they moved from Queens to Roosevelt Island. She wanted to be a writer when she grew up. When Jen was 16 she read about a film festival on the Lower East Side and her love affair with the neighborhood began. She wrote and starred in a short film, and performed her poetry at the legendary Bowery Poetry Club. There was some traveling—Paris at 19 years old and Buenos Aires at 22—but by 24, Jen was back in New York City. She goes to college, edits and writes children's books, works in a Lower East Side housing office, and is starting a literary development company. Jen has lived in her apartment since 2009.

"It feels like my apartment was handed to me by God. I never thought I would live in such a beautiful building. If it weren't for my apartment, I would have left New York a long time ago. Every time the stress and fast pace of New York alienates me, I look out my bedroom window at the skyline and I see the Empire State Building and the New Yorker Hotel sign, and it all reminds me that I was born here and I belong here. This apartment is a blessing and it never gets old."
—Jen

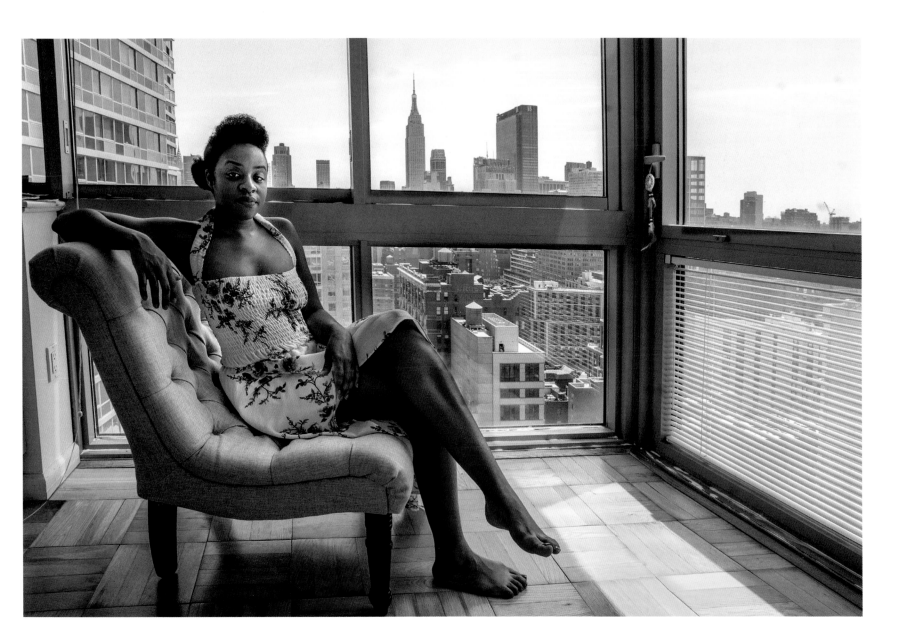

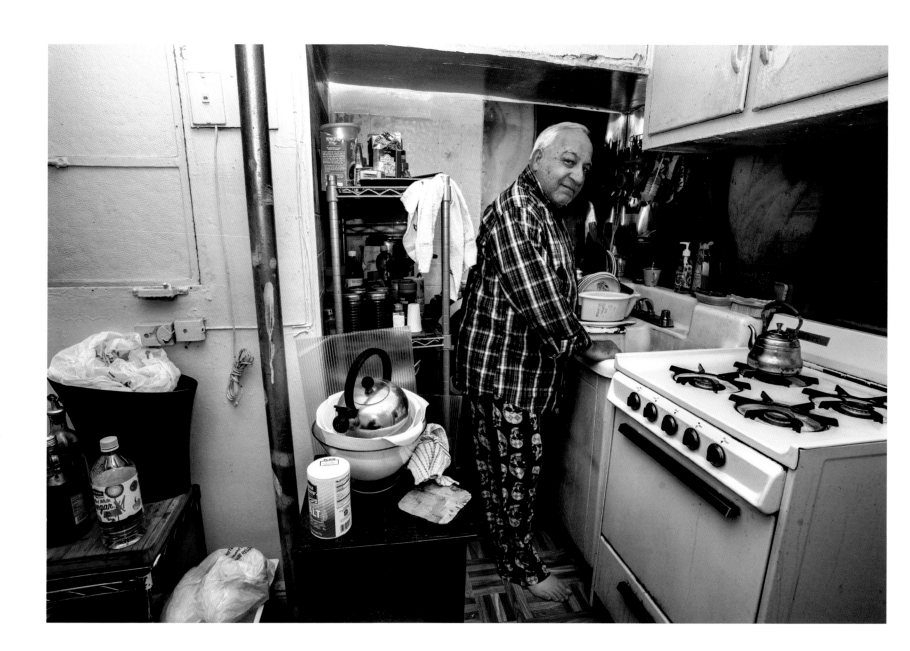

RACHID ALSATAF

Photographed at his home in the East Village on December 30, 2019.

Rachid was born in 1946 in Raqqa, Syria, one of nine kids for Abrahim and Adlah. Dad's family owned a very prosperous farm, but it was taken from them in 1958 by the Syrian government. They never got their farm back. Dad was also in the military, and Mom was a homemaker. Rachid did lots of things—he taught elementary school, he was in the military and fought in the war with Israel from '73 to '79, and he had a business buying and selling electronics. Wanting to move away from Raqqa, he spent some time in West Germany in the early '80s, before moving finally to Manhattan in 1986. By the late '80s, Rachid had settled into the East Village. He took this apartment in 1994 and lives there still. Rachid has been a cab driver for 20 years.

"I love the big town because I came from a small village. I love the big buildings, I love the noises, the bars, the restaurants, the lights. There is more going on here, more mystery. Always better to live in a mixed community. I love the diversity here. I do not live with just the Arabic community—I live with Chinese... with Greeks... with Ukrainians! I love it!"
—Rachid

BARA AND ROGER DE CABROL

Photographed with their two dogs Ludwig and Wilfred at their home in the East Village on September 13, 2019.

Bara was born on December 11, 1961, in London, England. She was the first of three kids for Claude Wolff and Petula Clark. Mom was a famous singer and Dad was her manager. They lived in Geneva and traveled a lot. Bara had a private tutor, but she went to school in LA and Las Vegas, too. She loved animals way more than people and always wanted to live on a farm. She was bored at school, but was really good at learning other languages. Bara lived all over the world and moved to Manhattan in 1994.

Bara and Roger met in 1994 and got married in 1995. They have two children together, Sebastian and Anabelle.

"I have so many souvenirs that people think are amazing, but they are nothing out of the ordinary to me. These days I love having a bad memory! It seems to me that after having lived all over the world, all roads lead to the East Village. I finally decided to take the plunge and move to Manhattan, after meeting Roger in 1994, and never looked back... We've been happily married ever since, with two beautiful children and two beautiful dogs! After changing apartments a couple of times, we got lucky and found our little gem of a place that we call home about 12 years ago."
—*Bara*

Roger was born in San Francisco in 1953, the only child for Alfred and Lillian. Mom was a mom and Dad worked in the airline business. Roger spent his childhood in San Francisco and Mexico City. When he was 11 he moved to France to go to boarding school. Roger knew early on that he would not be happy with a 9 to 5 job. He knew he wanted to be an artist. While living in Paris during the early '70s, he worked as an assistant to Salvador Dalí. They traveled around and spent a few months a year in New York City. At the same time, Roger opened the first recording studio in Ibiza, Spain. The studio stayed in business for about a year and a half, then he sold it to Judas Priest, the band. In the late '70s, Roger moved with Salvador Dalí to New York City. Soon after arriving, he partnered with Howard Stein and opened a club called the Rock Lounge in SoHo. That lasted about two years, and then he worked as a personal assistant for Mick Jones. That lasted about two years also. By the mid '80s, Roger had a record label and managed a few bands. Feeling exhausted by this point, Roger decided he wanted to live a normal life. He had studied at the École des Beaux-Arts in Paris and had already worked with his uncle Baron Fred de Cabrol and Jacques Grange, learning the interior design biz. He returned to those roots and got a job as an interior designer with Valerian Rybar in 1985. Rybar was called the "world's most expensive decorator" in 1972 and was known for his extravagant taste. Roger worked there for a few years and then he set out on his own. He has been his own boss ever since.

"We always lived downtown in the East Village. We finally bought our loft in 2007 in a building named the Carriage House—it was used for carriages and horses during the late 19th century. We own a floor, which has been photographed and published several times. We love our home, which is very special and different from so many other places. The neighborhood is like a small village and we are very happy here."
—*Roger*

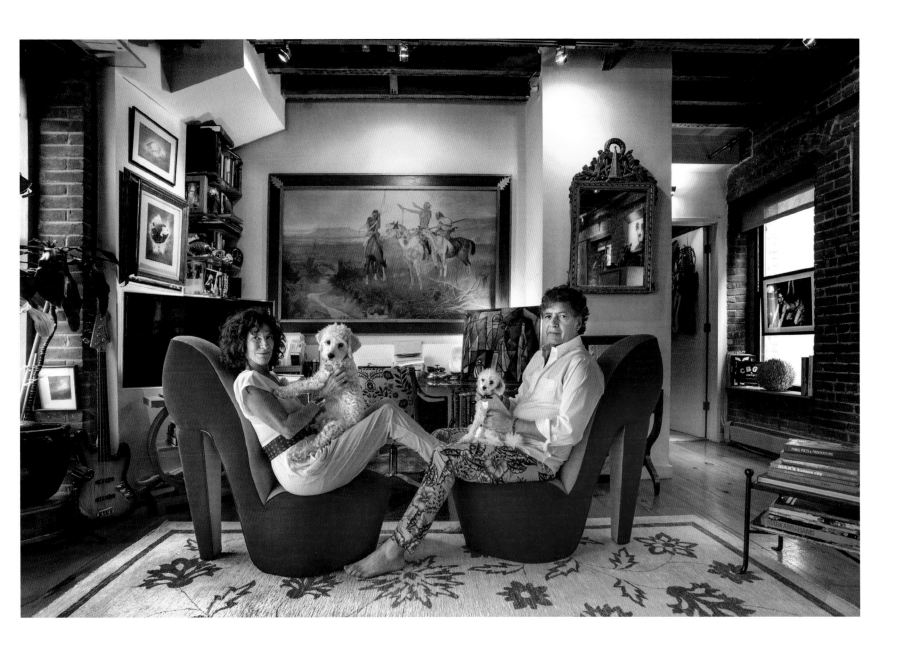

FRANCES PILOT

Photographed at her home in the East Village on March 24, 2019.

Frances was born in Chicago in 1949, one of two kids for William and Charlotte. Mom was an actress until she got married, and Dad was a corporate attorney. Except for math, something she was always on the brink of failing, Frances did well at school. She ice skated, played baseball, rode her bike, and wore corduroy pants under her dresses. By the time Frances was in junior high, she wanted to be a beatnik and live in New York City. By the time she got to high school, she was wearing the full beatnik ensemble: black turtlenecks and black plaid jumpers. She was hanging out in the Old Town "beatnik" section of Chicago and that involved skipping school once in a while. In 1980, after college and graduate school, Frances moved to New York City. She worked as a gallery girl, a house painter, a pornography writer, and a script reader, until she ultimately became a medical writer, which she did for 36 years. Frances has lived in this apartment since 1982.

"I plan to age in place in New York City because I can live cheaper here than anywhere else I'd want to live, thanks to rent stabilization. Believe me, they'll be taking me out of here in a black plastic body bag."
—Frances

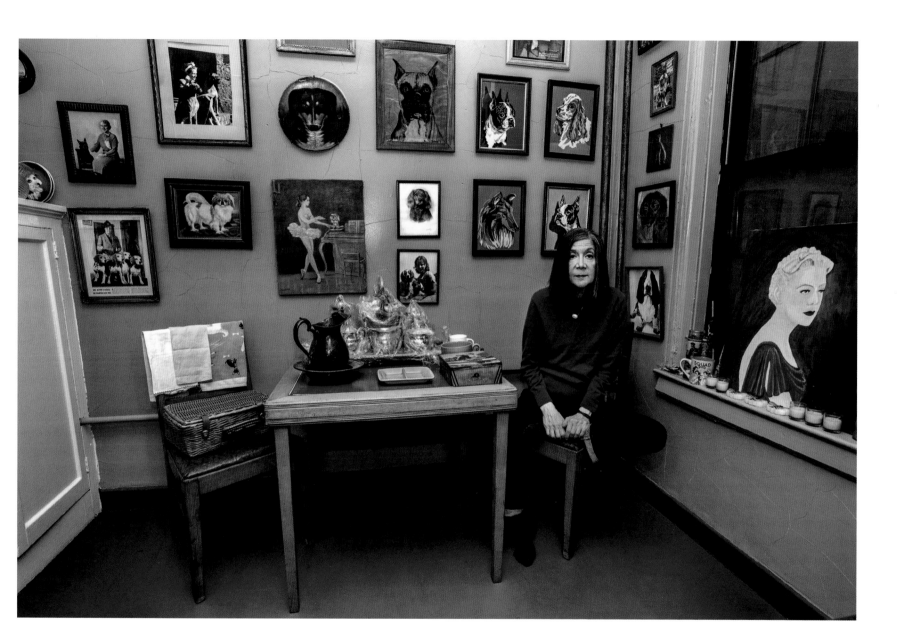

WILL DAVIS

Photographed at his home in Brooklyn on November 18, 2019.

Will was born in Liberia, West Africa, in 1981. He is the oldest of two kids for Winston and Musu. Dad was a civil engineer and Mom was a rehab therapist. Dad came to the US first, in the '80s, to get everything set up. Mom and the kids followed, escaping the civil war there in the early '90s. Will was 13. He spent his childhood in Liberia and the Ivory Coast, and has lived in Brooklyn ever since he landed in the USA. The most important thing to Will when he was a kid, was that his parents would be proud of whatever he turned out to be. He did well at school, excelling at history and basketball. He studied electromechanical engineering at college and graduated with an IT degree. Will lived with his family in Brooklyn until he was 27, as is often the tradition with African families. Will worked as a digital printer technician and a color specialist, and now he owns and operates a tour guide company, using motorcycles with sidecars. He moved into this apartment in 2019.

"There's a word in Portuguese called 'saudade' and it's very hard to translate into English, but it means a melancholy for a person, place, or thing when away from it, and it goes deep into your core. This is what I feel when I am away from New York City too long. I love to travel and have even flirted with leaving NYC before, but what always happens is, after a certain amount of time, I start to feel this 'saudade' for New York City. It becomes a part of you, and it becomes that great love of your life that, no matter what, you become cursed as you compare everyone else to her—and although they may suffice, they will never be her. New York City is that love for me."
—Will

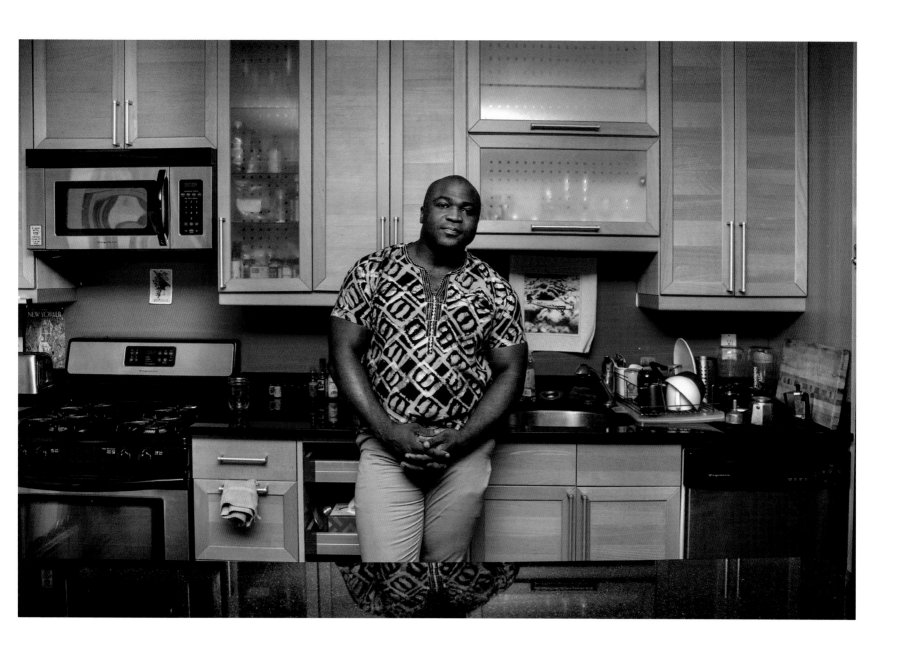

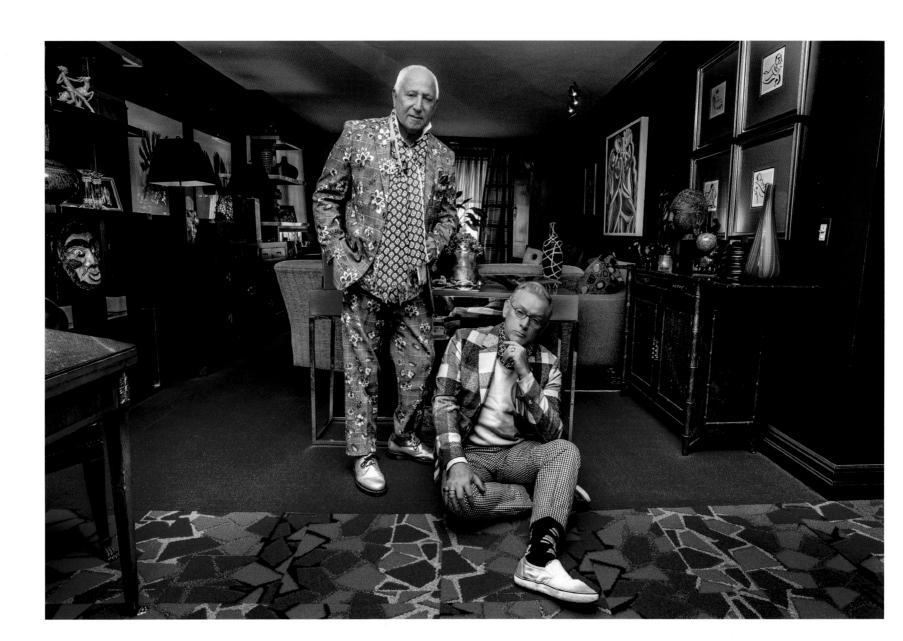

BEN MINDICH AND MONTGOMERY FRAZIER

Photographed at their home on Sutton Place on September 2, 2019.

Ben was born in the Bronx in 1942, the oldest of two boys for Anne and Sigmund. Mother was a housewife and Father owned the largest home service laundry in the Bronx. Ben spent his young years in the Bronx and his summers at camp. He was on the debate team, the basketball team, and boxed in high school. In 1959 Ben was voted 'Best Dressed' in high school. He studied business at college, then worked for the William Morris Agency—first in the mailroom with David Geffen, then in the TV division. Ben married Enid in the early '70s. He has two children and four grandchildren. They went their own ways in '82, and Ben moved to Manhattan. He worked as a catalogue coordinator, then in the fur business, and then at Saks Fifth Avenue, where he was an award-winning fine jewelry salesperson.

Montgomery was born in Roswell, New Mexico, but he didn't stay there long. He was the youngest of two boys for Larry and Helen. Mom was a housewife and Dad was in the Air Force, so he spent his youth as a military brat, traveling the world wherever his father was stationed. Once when Montgomery was in the audience at the *Ricky Lake Show,* a guest psychic named "Char" chose him out of the crowd and told him that his mother had been abducted by aliens once. It happened on a trip that she took with his older brother, who was only a baby at the time, while driving them from Anderson, Indiana, to Roswell, New Mexico. Montgomery doesn't have any personal UFO alien experiences, but he does believe that many humans have been abducted by aliens expressly for the purpose of cross-pollination between the human race and extraterrestrial species. Montgomery was a straight-A student and wanted to be an actor when he grew up. Once, as a boy, when he lived in Canada, he fell through the ice and almost died. Finishing high school in Colorado, Montgomery moved to Arizona. He washed dishes, was a busboy, and worked as a retail sales associate. In 1982 he moved to New York City. He worked as a fashion director at MTV and ETV. Now, Montgomery is the "Image Guru." He styles celebrities in TV and movies, and sometimes he's in the show, too. He met Ben in 2010.

Ben moved into this Sutton Place apartment in 2002 and Montgomery joined him there in 2016. They still live in this apartment.

"I love New York. We have an extremely social life with all the wonderful creative friends that we've cultivated. I've always been considered a 'stylish New Yorker' and I've been featured throughout my life in style sections of various magazines and publications. Most recently we both were featured in the New York Times *style section. We travel every year with one big trip and try to get away as often as possible."*
—Ben

"My heart is in New York, especially after 9/11. I will always be a New Yorker in my heart, soul, and spirit. We live in a modest but well-appointed apartment, with objects we've collected over the years on our travels around the globe. Home is where my heart is."
—Montgomery

JACKIE FERRARA

Photographed at her SoHo loft on April 9, 2019.

Jackie was born Jackie Hirschhorn, the oldest of two kids for Herman and Diana. She was born on November 17, 1929 in Detroit, Michigan. Dad was a salesman for a restaurant equipment store. They ate out a lot for free because the restaurants were his customers. Mom was a stenographer at the Department of Corrections in Detroit. Gramma lived with them and was always around if the kids needed anything. Jackie liked school and did well at class. She loved algebra and English grammar, and was a Brownie and then a Girl Scout, too. She started college in 1950, but only lasted six months. In 1952 she moved to New York City. Jackie worked at a bank and then at a theater company, before starting her minimalist sculptures in the '70s. She lived on the Lower East Side until 1971, then she purchased her loft in SoHo for $7,000 with a loan from her aunt. Her artwork is in major museums. Jackie still lives and works in her loft.

"When I was 19 and living in a dorm at Michigan State in East Lansing, I could get Symphony Sid on my radio only after midnight. He would say, 'This is Symphony Sid broadcasting live from Birdland at 52nd Street and Broadway in New York City' and I would get goosebumps. A couple of years later, I was living here and have never wanted to leave."
—Jackie

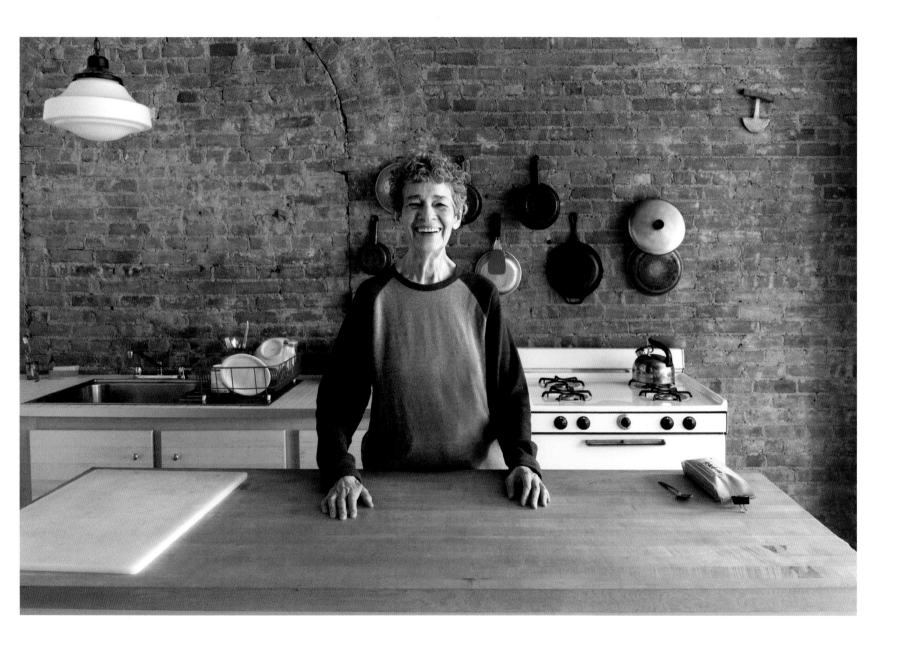

MEHAI BAKATY

Photographed at his tattoo shop in the East Village on September 5, 2019.

Mehai was born in 1972, the youngest of two boys for Linda and Mike. Mom was an office manager and Dad was a teacher and a tattoo artist. He grew up in the family loft on the Bowery when it was still the Bowery. He spent as much time as he could at his friends' houses in better neighborhoods, and remembers "the street prostitutes waving to all the kids on the school bus." He wasn't that great in school, but Mehai knew early on that he wanted to be an artist. At 15 he began his tattoo apprenticeship with his dad. That same year his father gave him his first tattoo. He left home at 17 and lived in a few other parts of the country before coming home to New York City to stay. Before Mehai settled into the tattoo business he renovated apartments, worked at a record factory, and also at a printing company that made prints for famous artists. When the city finally re-legalized the tattoo trade in 1997, he opened the tattoo shop with his dad Mike. Mike passed away in 2014 and Mehai still runs the shop.

"I love this city but it's admittedly difficult to cope with the current rate and level of gentrification. For working class people it's becoming harder to find reasonably priced places to live and entire neighborhoods are being displaced in the name of upward mobility. It's at the point where if you're lucky enough to have a decent apartment somewhere, you become too afraid to move. It would break my heart to leave the city but sometimes it's hard to imagine staying. Who knows what the future will bring, but I guess that's one of those things you learn living in New York."
—Mehai

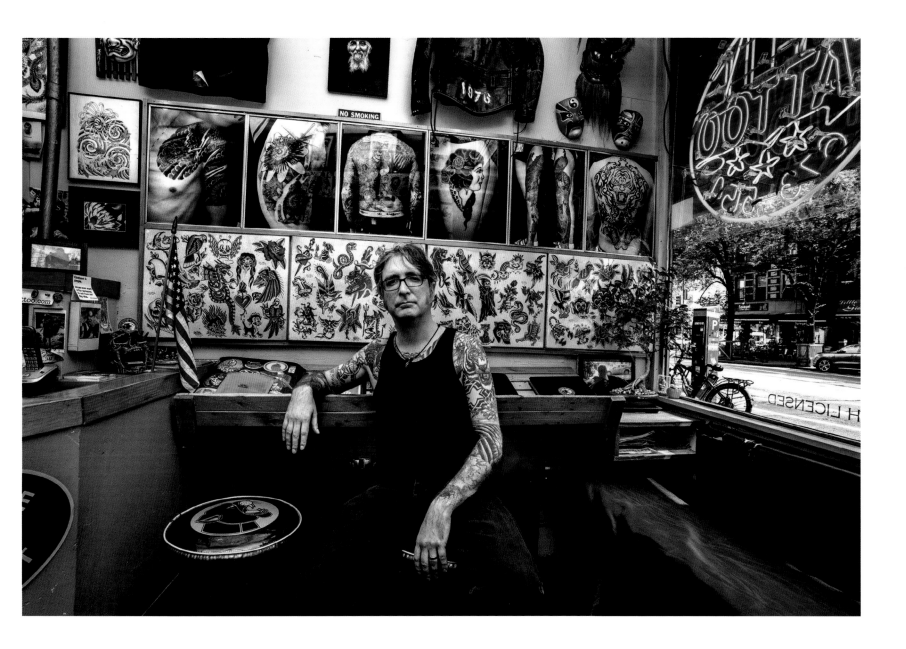

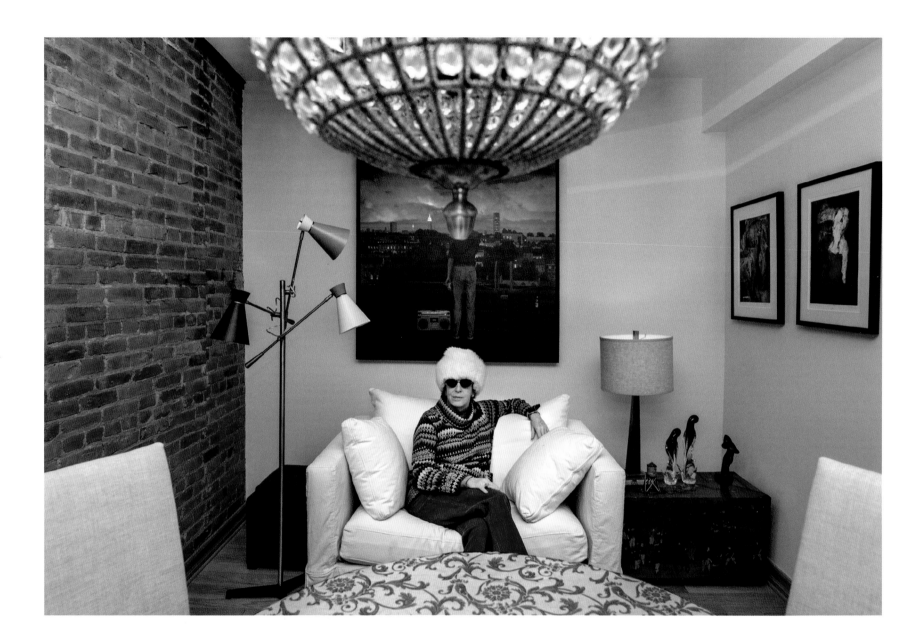

JANET HALPIN

Photographed at her home in Murray Hill on December 22, 2019.

Janet was born in New York City in 1951. She was the second of four kids for Joe and Zoe. Dad was an accountant for the Singer Sewing Machine Company and Mom worked as an admissions officer at an art college. Janet spent her childhood in Queens and then on Long Island. She wanted to be a "good person" when she grew up, and sometimes she wanted to be the Pope. She was a good student and did well at school. Janet was a tomboy. She played the East Coast tennis circuit and surfed. She delivered newspapers, sold greeting cards, cut lawns, babysat, was a soda jerk, and a dental assistant in training. That randomness continued throughout her life, as did the importance of being self-sufficient and independent. Janet majored in philosophy at Newton College in Boston, and in 1971 moved to Manhattan to finish her degree at Barnard. During those college years she worked as an au pair for Julia Louis-Dreyfus, aka Elaine, as we all knew her on the TV show *Seinfeld*. She was vice president of an international real estate development company and taught herself how to invest the money she saved. Janet moved into this apartment in 1975.

"In my teens I thought my life was being foretold by the next Beatles album. I was another baby boomer, hitching a ride on the Magical Mystery Tour bus. They broke up around the same time I moved to Manhattan to finish college at Barnard. My ages synched with the city's stages: 1970s—my 20s, marked by anarchy; the '80s—my 30s were decadent; the '90s were settling in and down; 2000s—marked by mourning 9/11 and the death of my mother; and the years that followed that decade—maturing. So, like Peter Pan's lost boys who never wanted to grow up or grow old, I stayed. It is here that I have been free to be me. I am a New Yorker. I have traveled the country and the world extensively for the last 15 years to make sure I have not made the mistake of settling and living only where I was born. New York City is not for everyone, for sure, and that's what I love about it. It's a city that used to cast out those who couldn't make it. We natives are proud of our ability to navigate the nasty and bask in the constant upheaval. Just look at the apartments in this book—no store-bought beauty or someone else's idea of how to live. Our homes reflect us, not some corporation's idea of what we should be."
—Janet

ALLAN TANNENBAUM

Photographed with his dog Jimi at his home in Tribeca on January 24, 2020.

Allan was born in 1945 in Passaic, New Jersey. He was the oldest of three kids for Howard and Helen. Dad was a salesman and Mom was an antique collector. Allan spent his childhood growing up in Passaic. He wanted to be a chemist and a soldier when he grew up. He loved Boy Scouts and did really well, advancing to Eagle rank. He also took ballroom dancing and water sports. Allan juggled his college years at Rutgers University with trips to California, where he taught himself photography, dropped acid, and bodysurfed. In 1968 he photographed Jimi Hendrix at Winterland, then hit the road, heading back east. In 1969 he moved to Brooklyn and five years later moved to Manhattan. Allan was a merchant seaman, a taxi driver, and a bartender, eventually becoming a prize-winning professional photographer in 1973. He photographed John and Yoko just ten days before John was murdered. He covered the 9/11 terror attacks in New York City and published his first book in 2003. Allan moved into this loft in 1974. He lives there with his wife Debra and their three chihuahuas.

"I love meeting and knowing people from all over the world. I hate the corrupt and inept government and greedy landlords. I've been lucky to have this loft on the nicest block in Tribeca since 1974. The space has enabled me to do all kinds of photography work, from studio shoots to large printmaking. It's also a time machine into the 1970s. Although New York City has changed a lot, I want to stay as long as I can and spend a lot of time out of the city, either upstate or in Europe. I've had a great life with lots of incredible experiences and great people. Photography has been the key to all of it."
—Allan

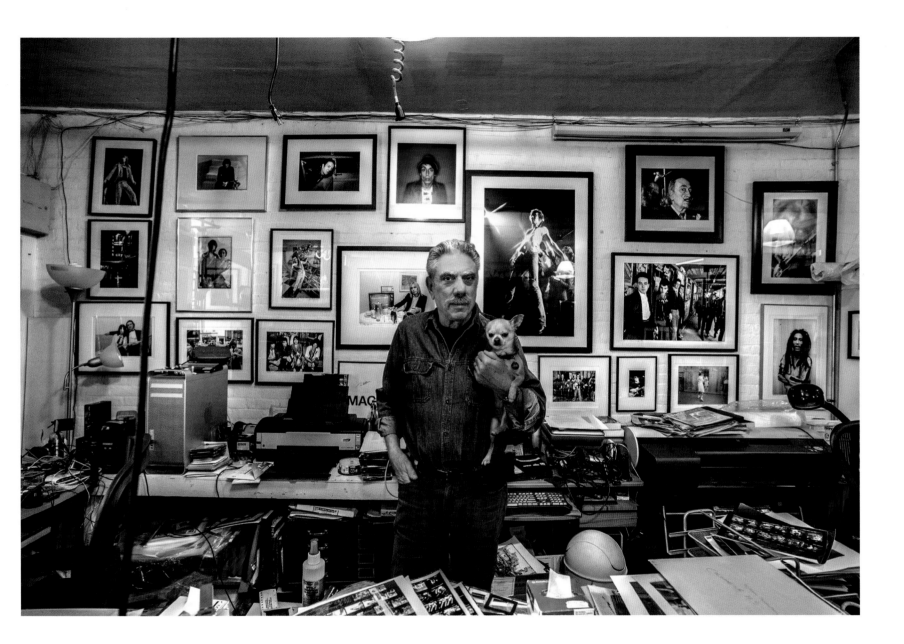

BRUCE MAZER

Photographed at his loft in Brooklyn on January 15, 2019.

Bruce was born in Livingston, New Jersey, in 1966. He was the youngest of two kids for Jack and Gloria. Dad was a dentist and Mom managed the practice. They were both from Brooklyn. Bruce spent his childhood in North Caldwell, New Jersey. He was a smart kid who always figured out a way to get by, but lacked the discipline to really excel. In spite of his low interest in school, he wanted to be a brain surgeon when he grew up. He sold shoes at a mall, worked as a salesman at Pottery Barn, worked as a waiter, and even tried his hand at house building. Bruce left for college when he was 18 and moved to Manhattan in 1989, living all over New York City: East Village, West Village, Upper West Side, Chelsea, and then Williamsburg, before mass gentrification ruined everything in 1991. He worked at an art gallery, then founded a software company for galleries and museums. Bruce moved to Miami for a while, but missed New York City terribly and came back. Now, he manages the global real estate for an international telecommunications company. Bruce moved into this loft in 2017 and lives there still.

"Even when I was living in Florida, I never stopped feeling like a New Yorker and I'm very happy to be back. I'm really happy with where I'm living in Brooklyn. It's much quieter than Manhattan near the Brooklyn Bridge Park and I take a ferry to work. It all feels very civilized."
—Bruce

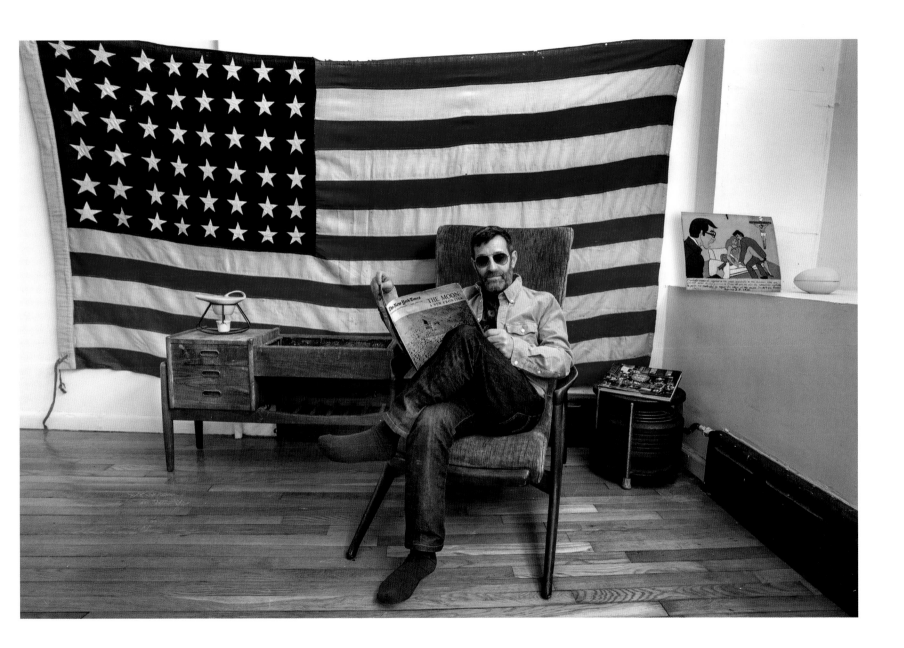

DOLORES KESTLER

Photographed at her home in the East Village on September 8, 2019.

Dolores was born in 1943 in Bushwick, Brooklyn, years before that neighborhood got groovy. She was the third born of nine kids for Emma and William. Although they were Catholic, Dolores thinks her grandparents were really Jewish and switched to "escape the Nazi purge." Dad was drafted to fight in the war, but as he was getting ready to ship off to Italy, Dolores's three-year-old sister was struck and killed by a car. The atomic bombs had been dropped on Japan and the war was coming to an end, so Dad got sent home for the funeral and was discharged. He worked at the Rheingold Brewery until he retired. Dolores lived in Queens until she was 24. She moved to Manhattan in 1967, living here and there in New York City, until she moved into this apartment ten years later. The night she moved in, there was a city-wide blackout that lasted two days. Her first crush was on Doris Day in *Calamity Jane*. Dolores worked as a secretary, an insurance sales person, and then worked at the Ford Foundation where they paid for her college. She got degrees in finance and economics, started a tax practice, then began growing sprouts and writing poetry. She became a massage therapist and an interfaith minister. She still grows sprouts and lives in the same apartment with her longtime sweetie Lillian, her dog Basil, and Dipsy the cat. Dolores and Lillian got married in 2018.

"Living in New York City has taught me to celebrate my differences and everyone else's. I have been sober now for 30 years and I love my life."
—Dolores

CHERIE NUTTING

Photographed at her home on East 11th Street on July 2, 2019.

Cherie Nutting was born April 1949 in Wellesley, Massachusetts. She was the only child for Barbara and Philip Nutting. Barbara was a showgirl in her youth and Philip was 'Ad Man of the Year' in 1948. She spent her summers in Maine, waterskiing and taking photographs. In 1960 her parents divorced and Cherie moved to Spain for four years with her mom, visiting Morocco along the way, with her Brownie camera in tow. Cherie lived on Cape Cod from 1972 to 1982 and worked there as a teacher. She taught Spanish and photography. In 1982 she moved to East 11th Street in New York City's East Village. Three years later, Cherie read *The Sheltering Sky* by Paul Bowles. Feeling a kinship with the book's characters, she started writing to Bowles. He wrote her back and asked her to visit him in Tangier. In 1986 she went, and they became lifelong friends. She photographed Paul Bowles for 13 years, until his death in 1999. Bowles bequeathed his apartment to Cherie when he died and she visits Tangier every year. Cherie met musician Bachir Attar in Paul Bowles' apartment in 1988, and later they were married. She brought him to New York City and in 1989 the band played on a Rolling Stones album. She and Bachir divorced in 1996, but remain best friends. Since that time Cherie has traveled all over the world with the band, photographing them at work.

"I love New York City because I see it as a truly modern mecca where all races mix and live together in peace. It is the only USA city where I really feel comfortable and have the opportunity to meet interesting people that have come to New York from all parts of the world."
—Cherie

STEVEN HAMMEL

Photographed at his home on the FDR in downtown New York City on September 22, 2019.

Steven was born in Bertha, Minnesota (population 500) in 1963. He was the youngest of eight kids for Herman and Lois. He has 28 nieces and nephews, 35 great nieces and nephews, and two great greats. Mom was a good farm wife and Dad ran the cattle farm. Steven knew he wanted to be an artist when he grew up. His mom and dad encouraged him to work on his talents. He loved being in a marching band, but wasn't that interested in sports. He rode the school bus for an hour in the morning and an hour at night down dusty gravel roads, dropping off kids at their family farms. He had friends in the school but they didn't hang out much after class because everyone had farm chores to do. When Steven was ten years old, his goal was to be the dairy princess butter sculptor at the Minnesota State Fair. Grateful that his parents never made him feel "less than" because he was gay, he graduated high school in 1981 and skipped out of town straight away, unscathed. Steven studied commercial art in Minneapolis, working as a guard at the museum there while going to school. He learned a lot about art at that job. When he moved to New York City in 1986 he worked as a waiter at the Trump Tower. He waited on Donald and his wife Ivana, and, later, on Marla Maples. Steven works as a decorative artist now for New York City apartments, does paintings for TV and movies, paints sets for the theater, and did all the glitter walls for the Beauty Bar chain.

"I love architecture and even though all the new construction in New York City is not so affordable anymore, I still enjoy watching the city transform itself. Many people say that NYC's best days are passed and that it was more exciting back in the day, but I believe it's still exciting and holds the same opportunities today for a 22-year-old as when I moved here at 22. Just different, but the same. My art and my apartment reflect my love of Americana and fondly harken to a childhood growing up on a farm. The contrast between my life in New York and that of my childhood has always piqued my artist aspirations. I plan to stay in New York City."
—Steven

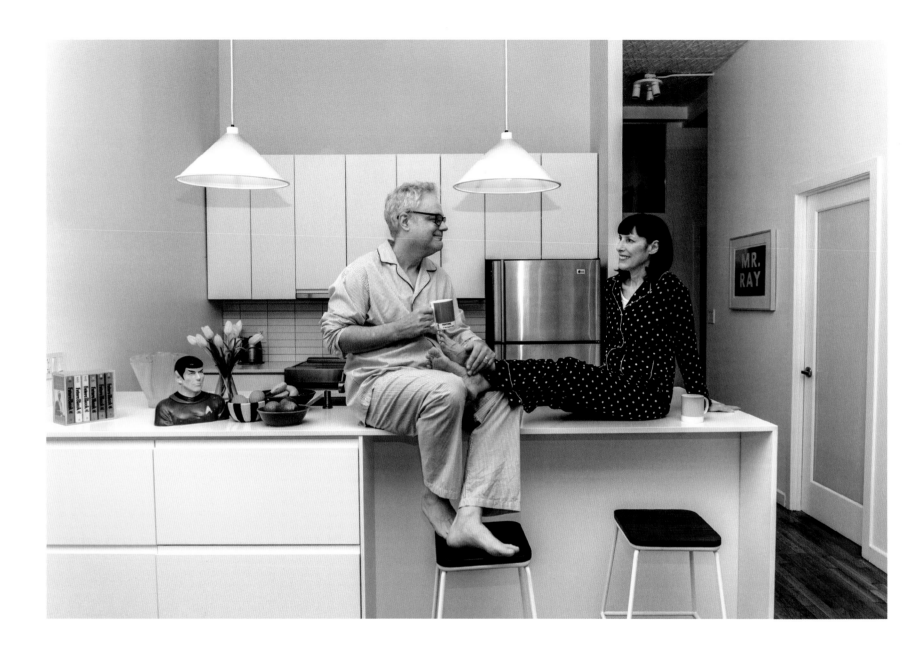

STEVEN SALZMAN AND ELLEN KAHN

Photographed at their home in Tribeca on May 20, 2019.

Steven was born the youngest of three to Harold and Delores in Queens, New York, in 1957. Delores was fabulous and Harold was a businessman, both from New York City. Steven spent his youth growing up in Queens and in 1965 they moved to Manhattan. When he was 18 years old, he went to college at Bard and studied painting. He also worked as a trader for a hedge fund. He moved into this loft in 1987 and is still a painter.

Ellen was born the daughter of Marjorie and Melvin Kahn at Swedish Hospital in Brooklyn in 1952. Ten minutes later, her twin sister Lynda was born. Marjorie worked at Hofstra University and Melvin was an insurance broker. Once the girls arrived, they left New York City and moved to Long Island. In 1970 Ellen left the suburbs and moved to Manhattan. She lived in umpteen downtown New York apartments until she moved in with Steven, where she lives still. She studied textiles and painting at college, had a band in the late '70s, exhibited her art videos, was animation director at *Pee-wee's Playhouse*, and won two Emmys for Creative Direction.

Steven and Ellen met in 1991 and married in 2014.

"I don't like going anywhere so far that I can't be back in Times Square by midnight."
—Steven

"Originally I had to live in New York for the art world. Now I could live anywhere because the art world has moved to the internet. I live in New York for my husband, our family and friends, and lifestyle. When you walk out the door in New York it is always exciting. One never knows what you will encounter on the streets: a parade, golden glows on buildings, budding flowers in the park, mountains of garbage bags, or someone pissing on your sidewalk."
—Ellen

BUDDY PAPALEO

Photographed at his apartment in the East Village on April 24, 2019.

Buddy was born Vincent Papaleo in Bensonhurst, Brooklyn, in 1961. He was the middle child of three for Theresa and Vincent. Mom was a diamond setter and Dad was a general contractor. Buddy spent his childhood in Bensonhurst, wanting to be a gangster when he grew up. He wasn't very good at school, so when Mom and Dad separated early on, he quit school in Grade 7, bringing home to Mom any money he could hustle out on the streets. Mom died in 1987, and in 1988 Buddy moved to Manhattan's East Village. He lived at two apartments on East 6th Street before moving into this apartment, where he lives still. Buddy lives with two coffins—one converts to a sofa when opened and the baby coffin converts to a bar when opened. He worked as a building superintendent and is now on disability. Buddy collects Jack Daniel's swag, and is legally blind.

"My building was recently purchased. The new owner offered me $200,000 to move out, but I said, 'No, I'm not leaving ever. New York City is my home and I'm staying.'"
—Buddy

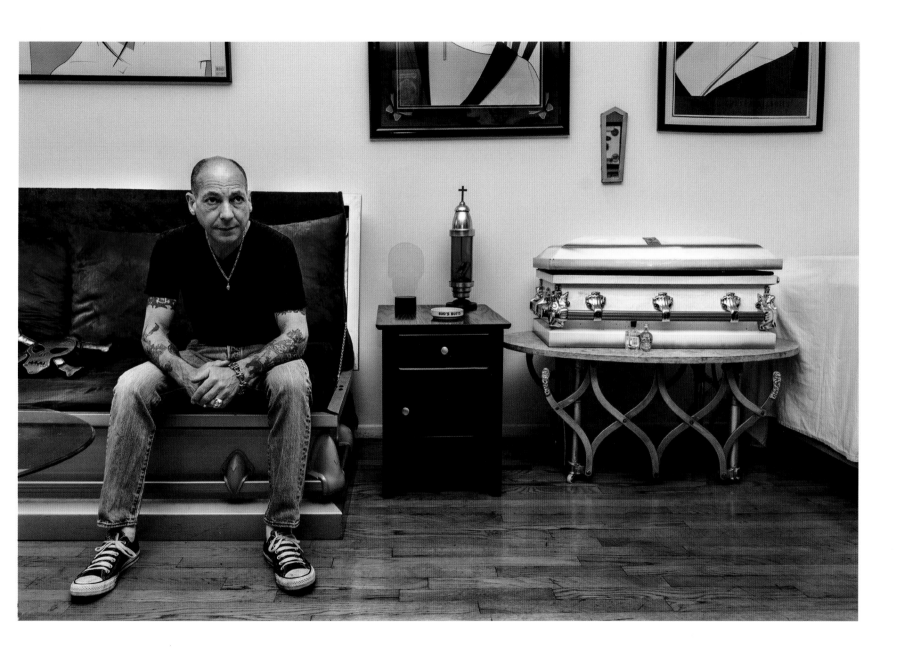

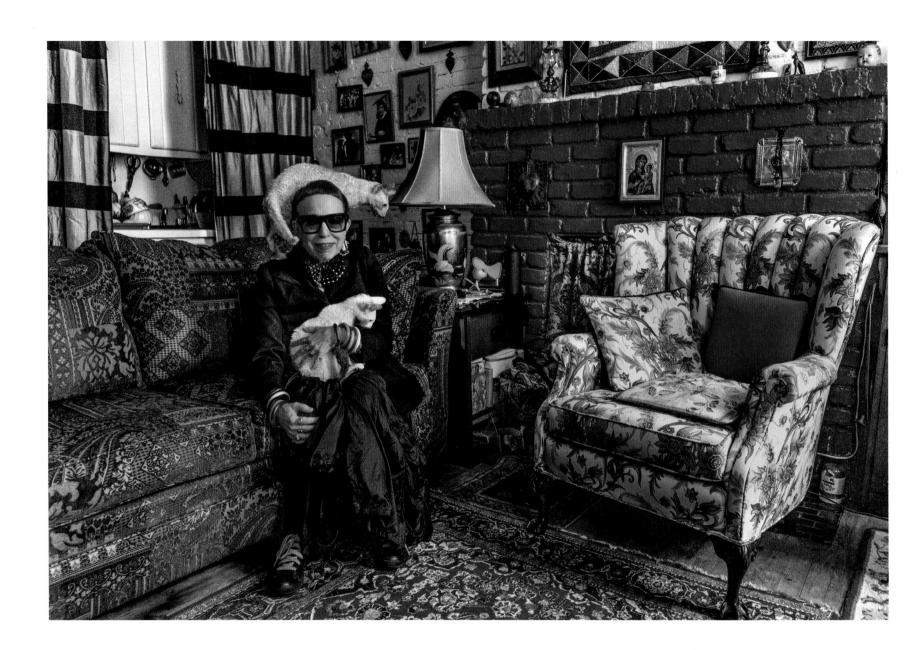

X BACZEWSKI

Photographed at her home on 1st Avenue on May 2, 2019.

X moved to New York City when she was six weeks old. Her mother brought her on the train in a laundry basket. She lived in Queens, then moved to Houston, Texas, because of her father's job with Shell Oil. When she was nine, the family moved back to New Jersey. In 1983 she returned to New York City as a performance artist with Lerner and Turner. She lived on the Lower East Side with partner and photographer Darryl Turner. After the 1983 East Coast relocation, she went solo, doing performance art, juggling music-related work with full-time magazine art direction, and producing two music albums. She was commissioned by the Art Institute of Chicago in the late '80s to do music for a film. Eventually she ended up as an associate design director at Estée Lauder for almost ten years. In 1989 she moved into this apartment and lives there with her two cats.

"When I moved into this tiny apartment I decided that I would think of it as a small parlor in a much larger home, rather than the small apartment that it is."
—X

KATE MAXWELL

Photographed with her dog Lilli at her Lower East Side apartment on January 4, 2020.

Kate was born in 1952 in Sydney, Australia. She was the first born for Alec and Carmen, who quickly put her up for adoption. Six weeks later, Frank and Carmen (same name as her birth mother) took her home to join their other three kids. Kate would become the youngest. Dad was a bank manager and Mom was a housewife. She spent most of her childhood growing up near the beautiful beaches of Adelaide. She went to an all-girls convent school from five years old to seventeen. When Kate was a little girl she wanted to be Audrey Hepburn. She also wanted to be a farmer's wife or a vet so she could spend her days with animals. In high school she was a member of an avant-garde drama club and put on plays by Eugène Ionesco. She was also in the debating club and on the track team. She learnt to sew in sixth grade and still sews to this day. Kate left home for good at 18. She studied drama and psychology at college, dropping out in her third year. She stayed in Australia for ten years after that, and in 1980 bought a one-way ticket to New York and boarded a plane. Her Australian accent was a shoo-in for her first job, answering the phones at an "escort service." It was all part of the New York she came to see: gritty, degenerate, and fabulous. She managed clothing stores, worked for a luxury travel company, traveling the world, studied graphic design, and eventually began her real career in the magazine biz. Kate moved into this apartment on New Year's Day in 1990 with a hangover. There used to be a window here with a magnificent view of the Midtown skyline. In 2010 a building was built next door and she lost her window forever.

"When I arrived in 1980, I thought I was doing the Australian travel thing but I never got any further than downtown New York, and before I knew it I had a life here. I've lived many lives in New York and being able to do that is part of why I'm still here. New York is like nowhere else. It can be a hard place to live, but it's a harder place to leave. In the past ten years I've thought about it many times. So much has changed and I miss the grit and edge. I never thought of myself as American but I'm 100 percent New Yorker."
—Kate

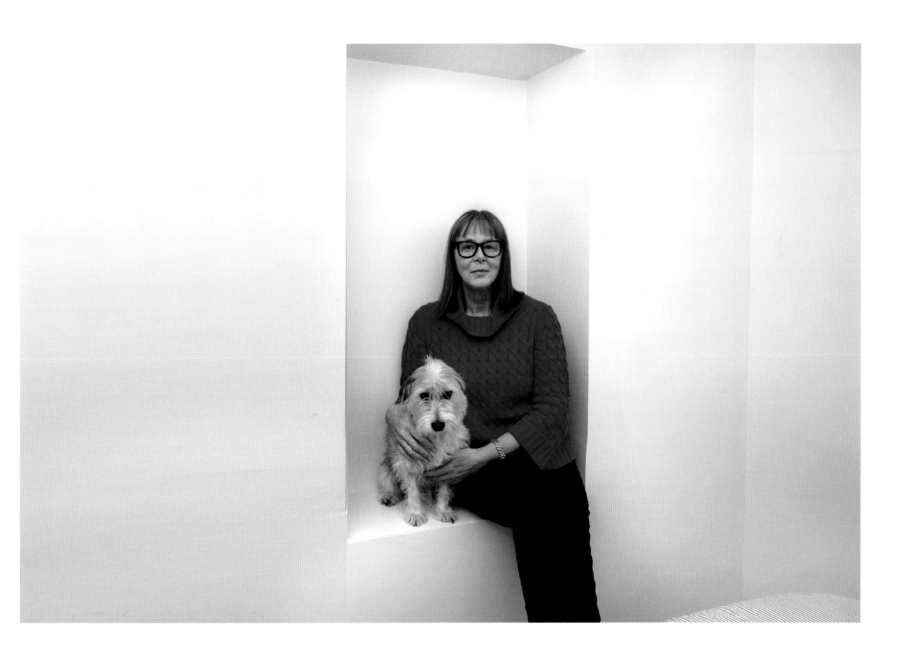

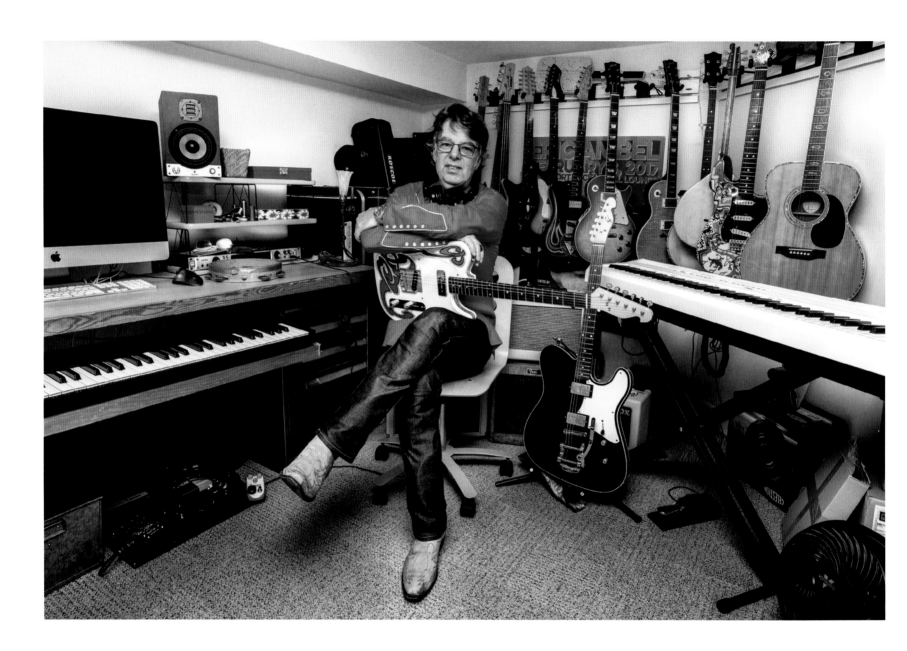

ERIC AMBEL

Photographed at his home in Brooklyn on August 29, 2019.

Eric was born in Aurora, Illinois, in 1957. He was the first of two kids for Melton and Carylsue. They were from Aurora, too. Dad was a Chicago real estate salesman and Mom was a housewife. Eric spent his childhood years between Batavia, Illinois, and a family lake house in Wisconsin. He was the smallest kid in school. Looking ahead, Eric wasn't sure how he would continue the splendor of his upper middle-class childhood life. He hoped to be an architect or maybe a dentist when he grew up, but Mom got him a piano when he was in third grade and that began his musical life. There was a stint in Wyoming to attend college and a musical pit stop in LA before Eric moved to Manhattan with Joan Jett in 1980, becoming a well-known New York musician. He went on to make records with his own band the Del-Lords and played in other famous people's bands, too. He was a partner at the legendary East Village bar, the Lakeside Lounge, for 16 years and also became a record producer, opening his own recording studio. Eric and his wife Mary Lee left the East Village and moved to this apartment in Brooklyn in 2010.

"I moved to New York City from LA with Joan in 1980. I felt like I could do in a day in NYC what took a week in Los Angeles. By the time we moved away from the East Village in 2010, it felt like it had narrowed so much. It wasn't the same varied place. There was a time when almost everyone we knew 'lived, worked, or played' in the East Village. By the time we left, we felt like 'The Teachers' when we went out to eat. I maintain my East Village connection with a monthly gig I play at a neighborhood bar. It's a very different place now. Bars are empty at midnight. The people who live there have to work hard to afford it."
—Eric

FRED BROWN AND CLAIRE FLACK

Photographed at their home in the East Village on April 22, 2019.

Fred was born the last of ten kids to Louise Cirillo and Herbert Brown in Jamaica, Queens, in 1968. His father left before he was born so he never met his dad, and his mom died when he was six. Fred bounced through three foster homes and his childhood aspiration quickly became "get educated and get out." After high school he moved onto college campus full time, studying architecture, and in 1988, after two years, he moved to Manhattan. It was still affordable in those days. He worked as a "bike messenger," as a dispatcher, plastics fabricator, stilt walker, bar manager, and then settled into a career of furniture building. Fred is also a serious diver.

Claire was born in 1966 in Manila, Philippines. She was the youngest of two for Ron and Danièle. Mom was French and Dad was a career diplomat. When Claire was young they moved to a new city every three years. She wanted to be a nurse when she grew up until her brother cut his finger, then she changed her mind. Claire did well at everything in school. She lived in Abidjan, Algiers, Athens, Geneva, and then Paris, where they stayed for ten years. Claire studied art history and photography at Sorbonne University, graduating with a master's degree. Her use of medical imagery for her photography eventually informed her career as a medical translator. In 1994 she left Paris, New York City bound, and landed in the East Village. She got this apartment in 1995.

Fred and Claire met in 1995 at Joe's Bar. He taught her how to play pool. Fred moved into this apartment to live with Claire in 2000 and they live there still.

"After 30 years in the East Village I can safely say that the only constant is change. This brings good and bad, but never boredom. I've met people from every corner of the globe right here in this tiny neighborhood. To me, it's the only part of Manhattan that actually still feels like a neighborhood."
—Fred

"I decided to move to New York City in 1994 because it was simply my favorite place to be: an imperfect grab bag of diverse and real people, mostly embracing difference and disregarding convention. I know it's still the reason I feel so at home here today, after a lifetime of not having one."
—Claire

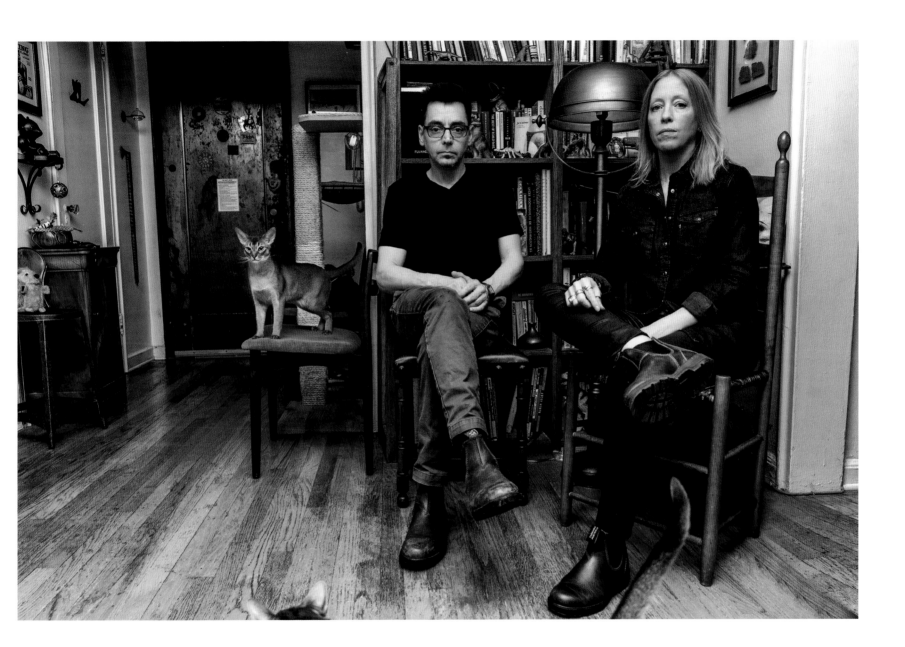

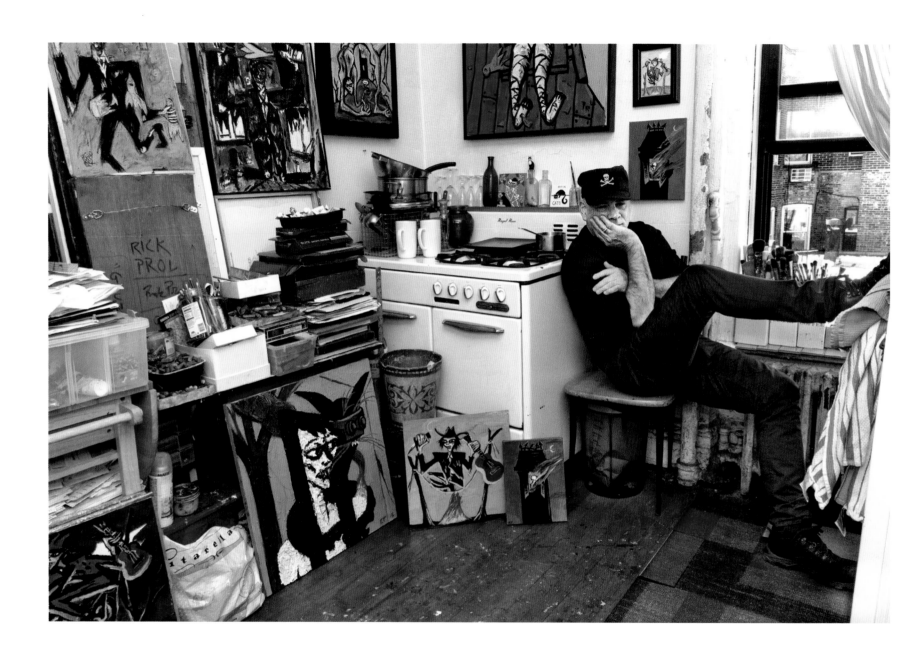

RICK PROL

Photographed at his home on West 11th Street in Greenwich Village on April 3, 2019.

Rick was born Ricardo Manuel Prol at Beth Israel Hospital in New York City on July 27, 1956. He was the youngest son for Yvonne Sherwell and Julio Prol. Mom was a flamenco dancer and Dad was a classical guitarist. They lived on 15th Street, then they moved to West 11th St in 1961. Rick attended Catholic school until he was a teenager, and won awards at summer camp for his rifle skills. He loved to dance, and also studied classical guitar and art. He delivered groceries to celebrities for Jefferson Market, he did dishes at Burger World, then was a waiter. In 1975 he left his family and got his own apartment on West 11th Street, where he lives still. Rick graduated college in 1980 and worked as a short-order cook. Rick painted and showed at East Village galleries in the early '80s. He was friends with Jean-Michel Basquiat and assisted Jean with what would ultimately be his final show in New York. Rick is still a painter and still lives in the same apartment.

"Life here is dramatically different than it was in the '80s, of course. It's basically unrecognizable. It's the exodus of the middle class and the gentrification that has completely altered New York, and it is a shame. A shame in so many ways. My neighborhood has never looked so beautiful, but at a price. It's a less dynamic scene all around. It's flatter and boring, really. Small businesses are pushed out, along with all the energy that comes from that level. The art world reflects this 100 percent."
—Rick

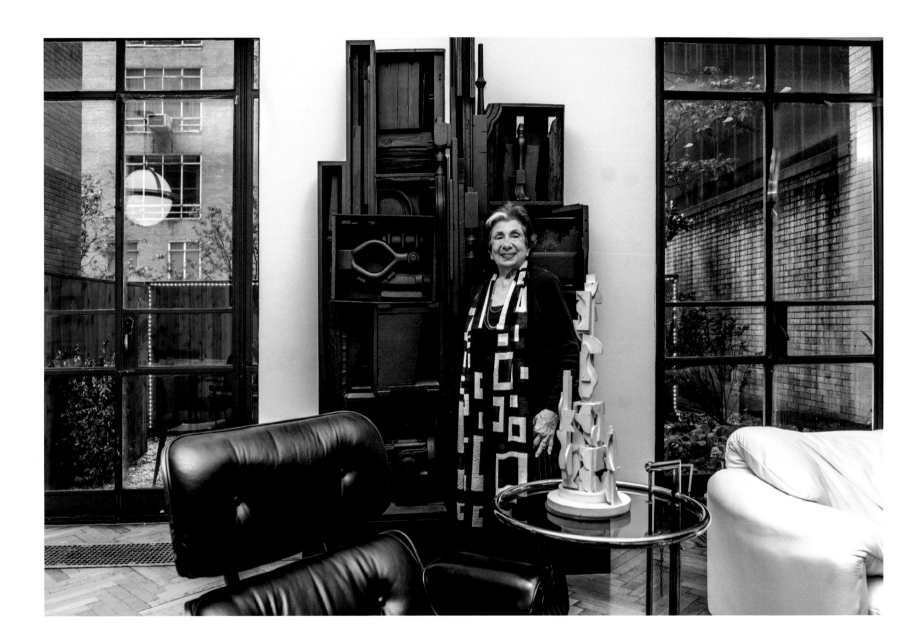

JOYCE POMEROY SCHWARTZ

Photographed at her home near the Museum of Modern Art, with her Louise Nevelson sculpture, on April 26, 2019.

Joyce Schwartz was born in Brooklyn, New York, in 1928, the daughter of an interior designer. Her grandfather was an affluent plumber and real estate developer. They had a chauffeur. She graduated from Hunter College in June 1949 and married Harold Schwartz, a dentist. They started their family of three straight away. In 1962 they moved to Manhattan, eventually moving to West 54th Street, where she lives still. Joyce opened the first gallery in New York that specialized in fine art photography. Joyce later formed her own public art curatorial consultancy. Her husband died in 2000. Joyce has five grandchildren and continues to work.

"I love being a world traveler, but I would never live anywhere but New York City, where I was born and raised. I spent my early years at the Brooklyn Museum learning to love different peoples and cultures, significantly African art and Native-American art. In 1975 we moved to the Rockefeller Apartments, near the Museum of Modern Art. Living close to museums is a life changer and life maker."
—Joyce

META HILLMANN

Photographed at her home in Manhattan's East Village on January 5, 2020.

Meta was born in 1993 in Berlin, Germany. She was the only child for Dorit and Andreas. Her parents met in 1989 in Berlin, the weekend the Berlin Wall fell, and Meta arrived three years later. They left Berlin when Meta was six weeks old and headed for Montreal, Canada, where Dad was going to do research at a university. A year later, they left Montreal and moved to Australia for a similar opportunity. Finally, in 1997, Dad was offered a job in San Francisco and they moved again. Meta spent the last three years of high school at a boarding school in Germany. She loved all kinds of dance and wanted to be Britney Spears when she grew up. She went to acting summer camp every summer, and by high school she wanted to be a comedian. In 2012 she moved to New York City. She attended the Fashion Institute of Technology, studying jewelry, and after a few neighborhoods, settled in the East Village. Meta worked at Alphabets—a landmark East Village gift shop—and has her own jewelry line.

"I plan on continuing to work in retail and further grow my little jewelry business in this city! My favorite thing about this city is that I can dress up like crazy one day and not care about my outfit at all the next, and no one notices. The days I feel good about myself and want to whip out a cute, fancy outfit I can, and get compliments and raise my self-esteem, and then on low days I can leave the house in leggings and a sweater and no one will go, 'Hey, why isn't she dressed up today?' As far as gentrification goes, I might be considered part of the problem, being young and not from here. But the neighborhood I grew up in in San Francisco has drastically changed as well. I used to be one of the only white kids in the neighborhood. There was a lot of gang violence. Now it's the trendiest neighborhood in San Francisco and no one can afford to live there, except for the techies. It's happening here too, except I wasn't able to see much of the 'before' here. I am intrigued to see how the place will look in another ten years, if hopefully the rent prices don't run me out by then!"
—Meta

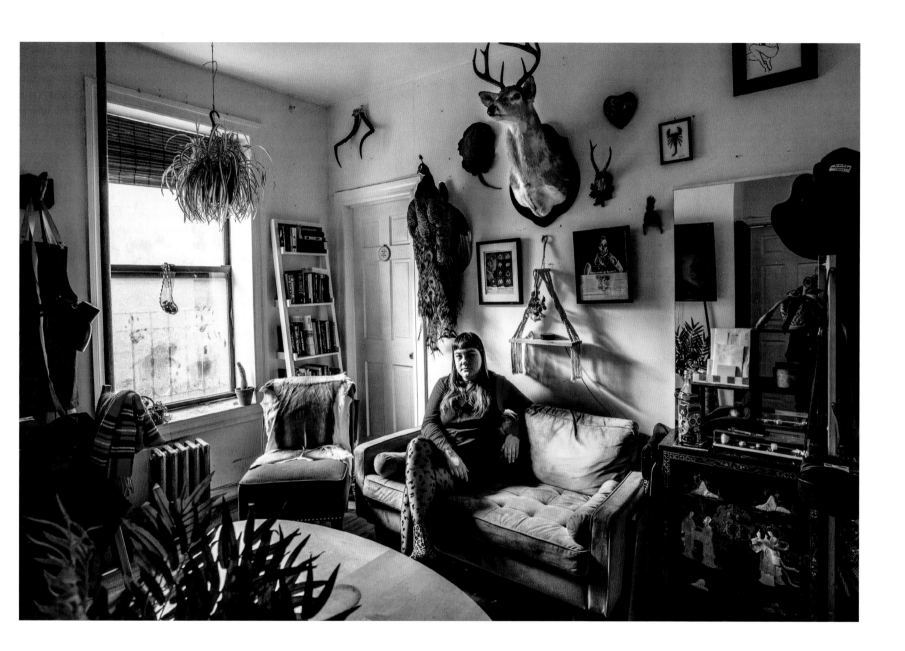

JAMES HAMMOND

Photographed at his home on the Upper West Side on July 2, 2019.

James was born in 1939 in Herne Bay, Kent, a small seaside town in South East England, just before the outbreak of World War II. He was the only child for Arthur and Maud. Dad was in the Foreign Service and Mom was a ballerina. He was shuttled between London and the countryside, depending on the bombing. When he was eight years old, he saw the "Exodus" come into Haifa harbor. James didn't do all that well at school and didn't have many friends. He went to university for a brief few months then joined the army, doing intelligence in Southeast Asia. He landed in the USA in the mid '60s by way of Hong Kong and then Brussels, becoming a stockbroker in St. Louis. By the late '60s, he had moved to Manhattan. James was married four times, once to a twin who was the runner-up for Miss Teenage Missouri. He has four sons from one of those marriages. James is a motorcycle racer, a photographer, and a collector of street art. He has lived in this apartment for 20 years.

"I was a misfit in England, so I moved to America more than 50 years ago. I was out of the loop even when I was in the loop. But I love New York and have stayed here. I'm glad I moved out of London. That said, we now live in an increasingly homogenized, commoditized, pigeonholed, and indexed world, and I predict that quite soon we will be living in safe towers that will offer vertically integrated living, catering to every aspect of life. Rather like the lifestyle of ants and bees."
—James

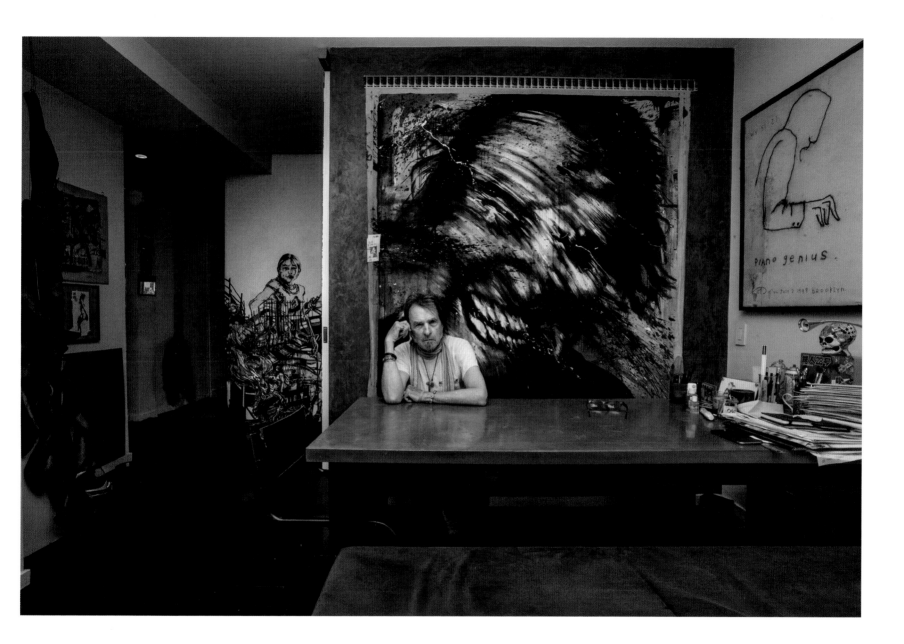

STUART ZAMSKY AND KIM WURSTER

Photographed with their sons Owen and Zachary at their home in the East Village on June 9, 2019.

Stuart grew up in Philadelphia, the oldest of three kids, and Kim grew up in Indiana, the oldest of four. Both of them studied drama at college, and in the '80s each moved to New York City to act. They met working on a theater production in 1990. Five years later, they opened White Trash, an East Village vintage furniture shop. Two years after that, they moved into this apartment and started a family.

"I love New York. Really. It does seem like a playground for the rich, though. And I miss the vibrancy of the no-pay arts scene. There used to be hole-in-the-wall theaters everywhere, performances in vacant lots, and thieves' markets. Now there are five-dollar coffee shops for bro-chicks. New York kind of ruins you for most other places. It's so vibrant and full of life, energy, food, and culture."
—Stuart

"I vacillate between wanting to run away and live some rural lifestyle, and thinking there is no way I could ever leave. I am tired of not having enough space. Many 50-year-old women fantasize about George Clooney; I have dreams of a washer and dryer. That said, we have lived a great existence, and I don't think other aspiring artists are able to do that now. We always had this cheap apartment. We have never made much money but because of the low rent we were able to save a bit to travel and send our kids to interesting camps and schools. I am truly grateful and yet often sick of it. But I think back to the saxophonist neighbor who came out on his fire escape one night to play 'Happy Birthday' to the boys, and I realize those are some pretty classic memories that have led to a pretty interesting life."
—Kim

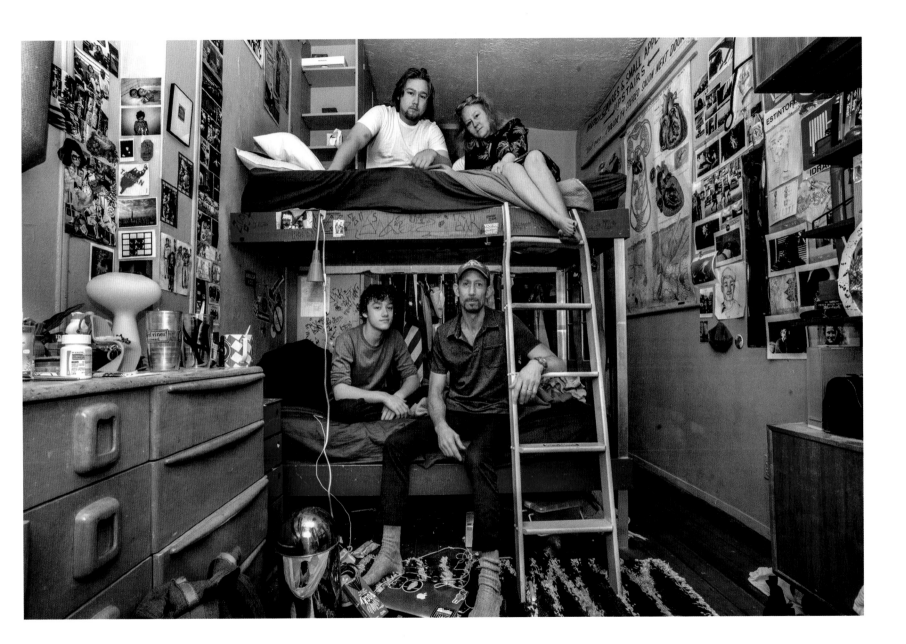

MARIA HEREDIA

Photographed at her home in the East Village on September 17, 2019.

Maria was born in Puerto Rico in 1945. She was the third of four kids for Felicita and Pedro. Mom and Dad both worked to make ends meet. Dad worked at a transistor radio factory. When Maria was four, they split up. Unable to care for her and her sister, Dad sent them off to New York City to live with his brother in Harlem, but that didn't last too long. The girls bounced around, living with different relatives. Finally, at seven years old, Maria and her sister were placed in a large state-run orphanage in Brooklyn, where she lived with her sister until she was 14. Maria wasn't that great at school, but loved sports and was on all kinds of teams. Meanwhile, her mom had moved to New York City, so when the girls got out of the orphanage, they moved back in with her. In 1966 Maria married Arnaldo. He was a musician, a drug addict, an alcoholic, and a cheater. They moved to the Lower East Side and had two children together, Christine and Justina. In 1978 they found a better place in the same neighborhood and moved in. The marriage ended in 1990, but Maria kept the apartment and lives there still. She worked in banks most of her life, except for a job at a factory assembling pens that she quit after just one day. She also worked as an "abandoned baby" holder at New York City's Bellevue Hospital.

"The fact that I didn't become an official psychiatrist doesn't bother me too much. My life experiences have allowed me to help many, many people with their problems. I've lived on the Lower East Side for 59 years. This is my forever home and I wouldn't live anywhere else. Even back in the horrible East Village drug days, when the neighborhood landlords were burning down their buildings to get rid of the Latino and African-American tenants, I stuck it out because I knew I was here to stay."
—Maria

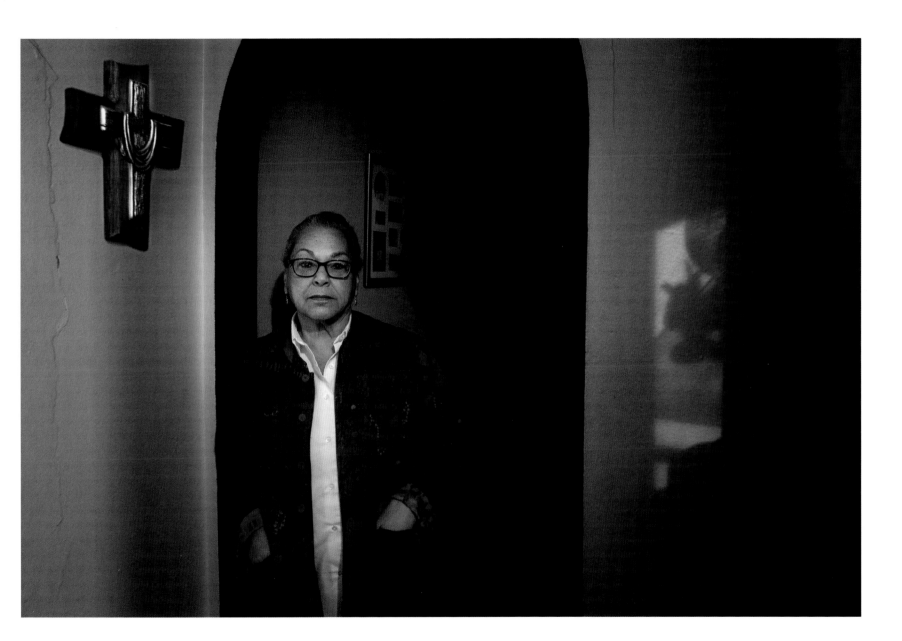

MICHAEL McMAHON

Photographed at his East Village apartment on August 22, 2019.

Michael was born in 1960, the third of five kids to Phil and Lynne, in the middle-class suburbs of Pittsburgh. The family business was steel and iron, as in "my father steals and my mother irons." He was an altar boy who spent time drawing and listening to sports talk radio. Phil wanted the kids to learn capitalism, so Michael shined shoes, delivered newspapers, and served as a soda jerk. When his older sister Amy returned from art school in New York City for the summer, with *Rock Scene* magazine, stories of CBGBs, and 45 records of the Ramones, Sex Pistols and the Residents, Michael's life was changed. He graduated from high school and 14 days later, with his newfound understanding that he, too, was a misfit, he packed his plaid suitcase and moved to New York City. It was 1978. He went to college and from his dorm window he could see Andy Warhol's Factory. He hung out at Max's Kansas City and worked at a nightclub, alongside his sister. He moved into this East Village apartment in 1980 as someone's roommate for $333.33 a month, and he lives there still. He supported himself by illustrating covers for *Screw* magazine, fasting on Mondays to save money, and then traveling around with Amy in a hillbilly band they started. Michael works at a private investment firm now, and his band plays at night at an East Village tiki bar. He has never owned a mobile phone.

"Now, 40 years later, New York City isn't quite so grimy, isn't nearly bankrupt, and the East Village is no longer the epicenter that it once was, but I'm still here. I still perform regularly in a hillbilly band and still wear thrift-store clothes. I still live in that same railroad apartment, even if the days of a steady stream of roommates (22 in 12 years, if I remember correctly) are long gone, thankfully. I have a reasonably cushy job that I've had for decades, that isn't particularly interesting or demanding, but it has dental and allows me to still kind of live like I'm on vacation."
—Michael

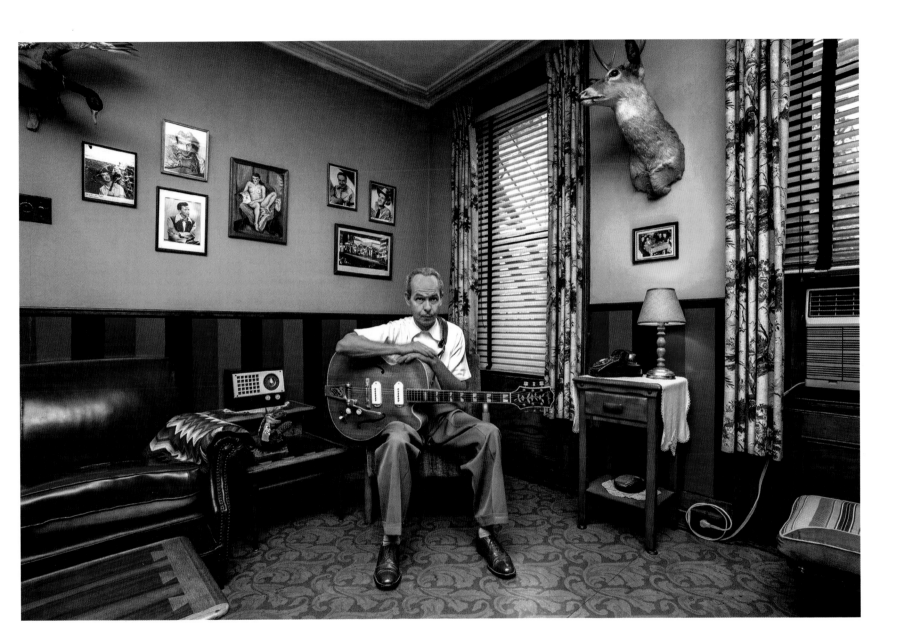

MICHAEL RIEDEL

Photographed at his home in the West Village on June 21, 2019.

Michael was born in 1966. He was the first of two kids for Robert and Marilyn, and grew up in Geneseo, New York. Dad was athletic director at a college and Mom was a librarian. Michael was really smart when he was a kid. Although he wanted to be a politician and lawyer when he grew up, things took a different turn. Now, Michael is a Broadway theater critic, a broadcaster, a columnist, and book writer. He's also been on TV a few times. He moved into this apartment in 1997. The realtor told him the value of his apartment wouldn't increase that much because it wasn't close to the subway. That is now a very funny New York real estate story.

"I moved to the West Village in 1996 before all the celebs got here and ruined the neighborhood. It used to be affordable. Now it's for the one percent. My favorite restaurant back then was The Black Sheep. It wasn't fancy, but the meatloaf was good. The costumers were older gay men, bald with beards, and dressed in flannel shirts and jeans. Some of them sat by themselves, drinking a martini. They had a haunted look. I wasn't sure why at first, but then it occurred to me that they were the survivors of AIDS. They lived, while so many of their friends and lovers had died. The Black Sheep became Wallsé, an excellent Austrian restaurant with the best Wiener schnitzel in town. I ate there the first night it opened. There was only one other diner: Lou Reed."
—Michael

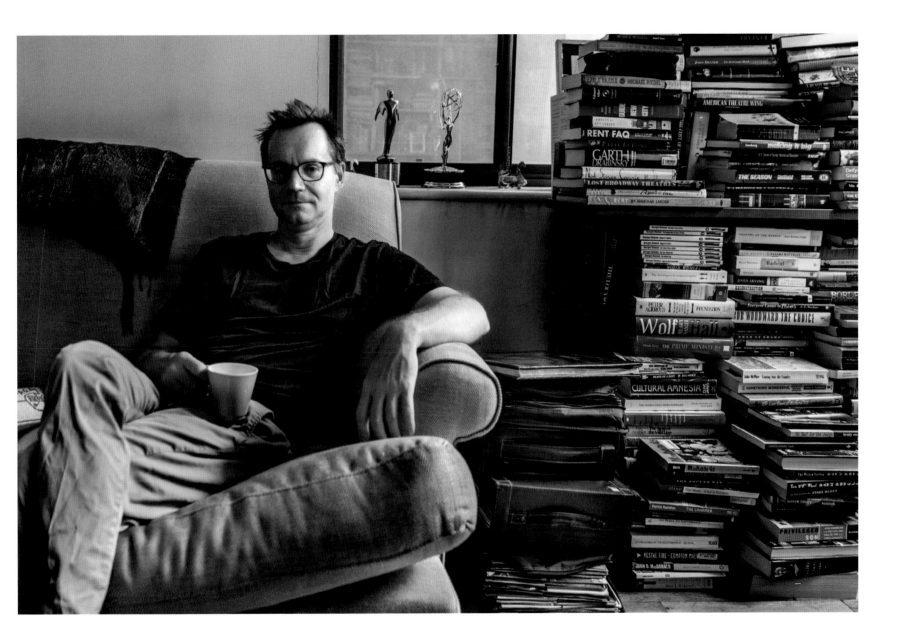

PENNY ARCADE

Photographed at her Lower East Side apartment on October 30, 2019.

Penny was born Susana Ventura in 1950 in New Britain, Connecticut. She was the oldest of four for Vittorio and Antoinette. Dad was a truck driver and Mom sewed clothes in a sweatshop, both hailing from Italy. Susana spent her childhood in Connecticut, first as an honor student in elementary school, then later dropping out of high school, never to return. When she was little she wanted to be an actress, and sometimes an archeologist, when she grew up. She left home the first time at 13, winding up in a Catholic reform school, and then again at 16, running away with a "carload of queens" to Provincetown. It was 1967, the summer of love, so she stayed for the summer. Leaving there, with a two-week pit stop in Boston, she ended up in New York City's East Village. She spent her first year in New York City homeless. Susana did some modeling and sold shoes on Orchard Street. Eventually, she was taken in by a friend she met when she was in Provincetown. He took her to the Playhouse of the Ridiculous, where she started doing theater professionally. In 1968 Susana Ventura's stage persona, Penny Arcade, was born. Penny is a performance artist and a poet. She is the author of ten scripted performance plays and hundreds of performance art pieces. Her work focuses on the outsider, those marginalized by society. She moved into this apartment in 1981 and lives there still.

"I am part of the last art avant-garde of the 20th century and part of the last Bohemian culture of New York's East Village. Once there were a lot of us. Bohemianism is a culture of values—you can no more be a bourgeois bohemian than you can be an atheist Catholic."
—Penny

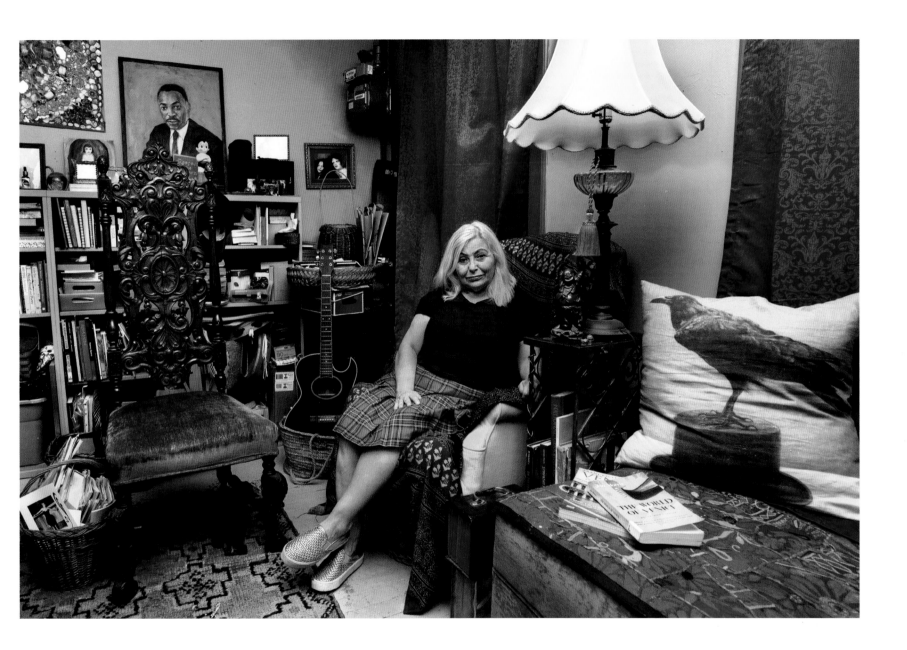

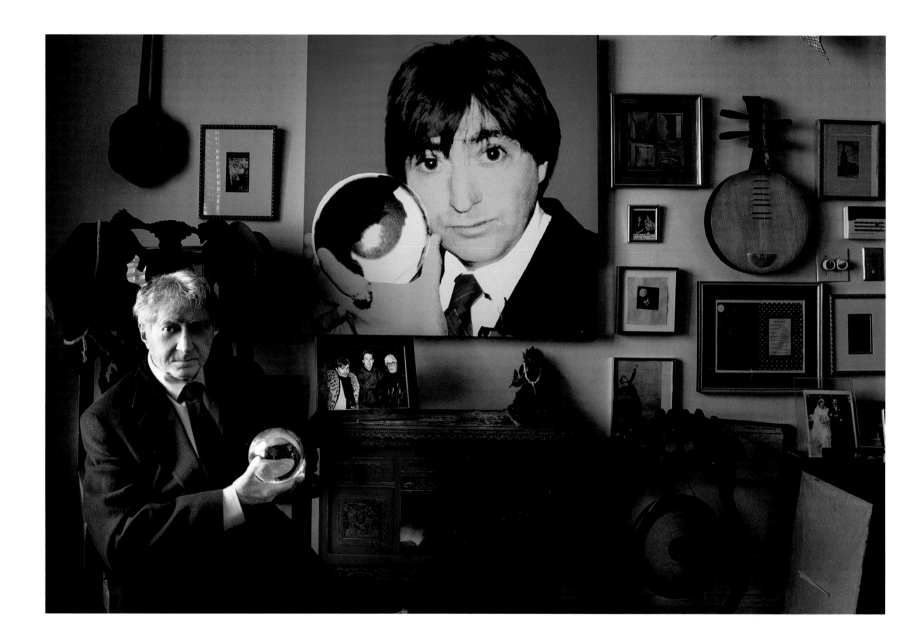

FRANK ANDREWS

Photographed at his home in Little Italy, with his Andy Warhol portrait, on September 23, 2019.

Frank was born in 1941 in Buffalo, New York. He was the oldest of three kids for Andrew and Mary. Mom and Dad owned an Italian restaurant in Buffalo called On The Terrace. Mom was born in the USA, and Dad came over from Sicily when he was six months old and they never went back. Frank didn't do all that well at school, but his mother was encouraging nonetheless. When he was little he wanted to be Marcel Marceau when he grew up. One night, when Frank was ten years old, a family friend who had died that day appeared at his bedside, as an apparition, to say goodbye. When he told his mother the next day, she was unperturbed, saying only that he should not tell anyone what he saw. Frank left Buffalo after high school on a bus bound for New York City. He stayed at the YMCA and later lived in the West Village, before buying the house he still lives in, in 1967. He worked as a waiter, and worked on Wall Street, then he started doing psychic readings at dinner parties. It didn't take long until Frank was the psychic to the stars: Grace Kelly, Louise Nevelson, Yoko Ono, John Lennon, Francesco Scavullo, and so many more.

"New York City enabled me to do the work I'm doing. It is a real home. Living and working here allowed me to meet all these incredible people: the mobsters, the movie stars, the judges, the lawyers, the doctors, the nuns, the priests... I ran the gamut. I would never have been able to do this had I stayed in Buffalo."
—Frank

FLLOYD NYC

Photographed at his home in the East Village on October 26, 2019.

Flloyd was born Bryan Chalmers in Tampa, Florida, in 1964. He was the second of four kids for Jerry and Eleanor. Mom was a waitress and Dad worked for Delta Airlines. Even though they were a very middle-class family, and Bryan was just a kid, he felt that he was a jet-setter. School wasn't great for Bryan. He was good at math, and art too, but he was ostracized and bullied. At 14 years old he discovered gay bars and drag shows. He fit in there and his course was set. When he was 18 years old he met RuPaul and a 20-year best friendship began. They moved to New York City together in 1983 when he was 19 and they couch-surfed for many years. He became Flloyd and worked as a go-go dancer at New York City's Pyramid Club, did drag performance art, was in bands, and worked most successfully in the S&M business. Flloyd has made several short films, a television show, and a feature film. He now pays his bills with Sister Green, his cleaning company. With a little help from his friends, Flloyd got this apartment in 1990 and lives there with his boyfriend Angelo.

"Shortly after moving in I discovered the person before me paid one-fourth of what I paid and I spent the next two years in court. Afterwards, my rent was lowered to an insanely low amount. This has given me the ability to live the life of a starving artist. I live a very sober life, and I enjoy cooking and baking, and watching old movies with my boyfriend."
—Flloyd

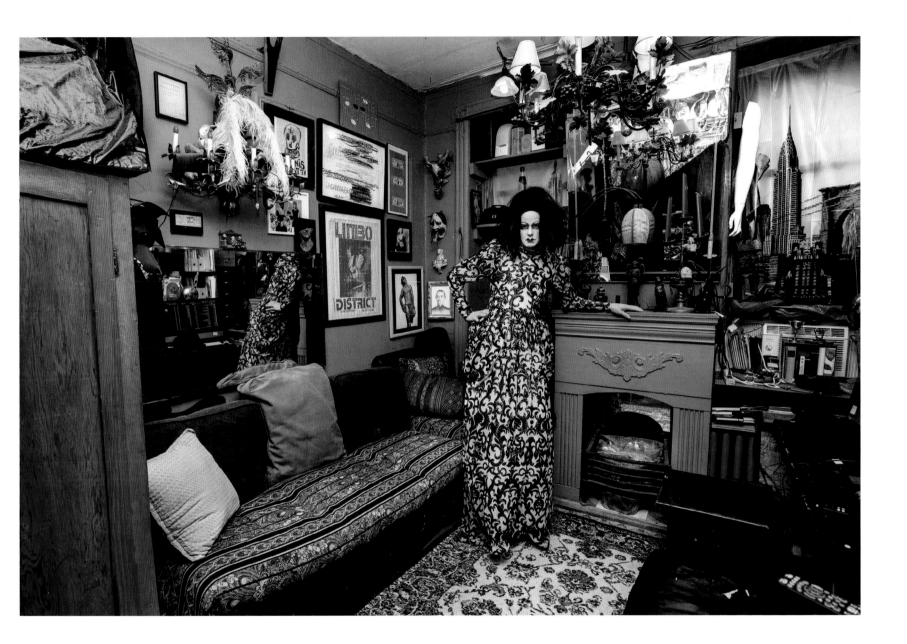

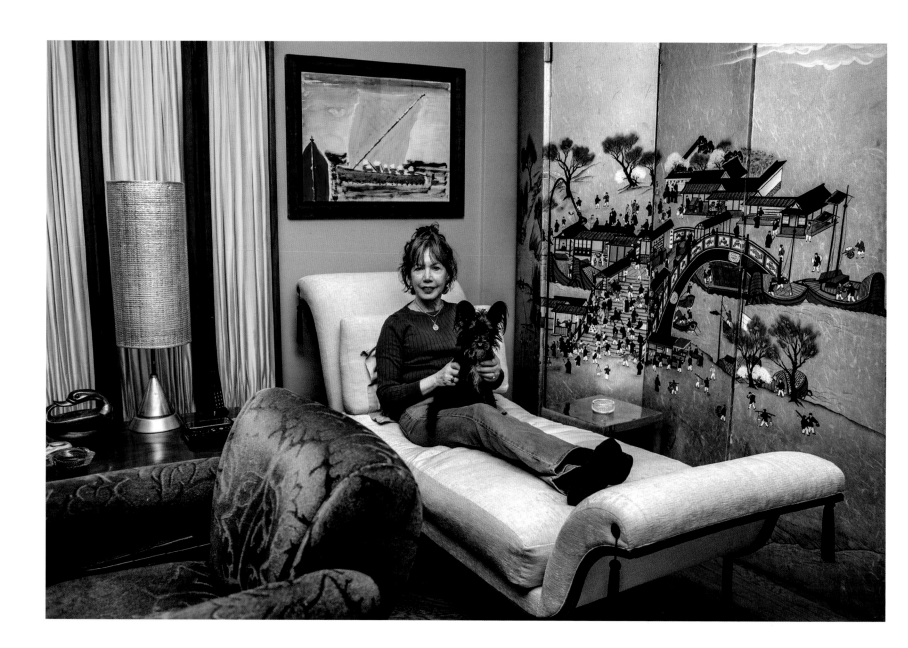

JEWEL WEISS

Photographed with her dog Coco at her home on Manhattan's Upper West Side on November 22, 2019.

Jewel was born in 1947 in Newark, New Jersey. She was the oldest of two girls for Edythe and Marvin. Dad owned a tavern and then later a liquor store. Mom worked as a bookkeeper in her parent's bakery, and then for Dad as his bookkeeper. Mostly Mom socialized. Jewel was a good enough student and loved reading and art. She wanted to be a cowgirl when she grew up. Jewel graduated from college with a degree in TV and radio, married her childhood sweetie, who was a rock musician, and moved to New York City in 1970. She worked in her dad's liquor store, first cleaning the place and then as a bookkeeper. She also worked as a file clerk at a chemical company, as a bookkeeper at a plastics company that made tchotchkes for theme parks, as a receptionist at Vanguard Records, as an assistant at a film company, as a receptionist at a pediatrician's office, and did odd jobs for the original cast at *Saturday Night Live*. Finally, in 1981, she found her niche as a cotton pit broker on the Commodities Exchange. Jewel worked in the commodities futures business for 30 years until she retired. She started ballet lessons last year, and has lived in this apartment since 1993.

"Just say 'yes'—the opposite of what Nancy Reagan used to say. When I was younger and wilder I used to refer to New York City as 'the wild, wild East.' I love all the possibilities in New York City—plenty to do and I like the diversity. As far as the changes in the city, it happens, nothing remains static—look in the mirror. Unfortunately, housing has become more expensive and the city is more crowded than it used to be."
—Jewel

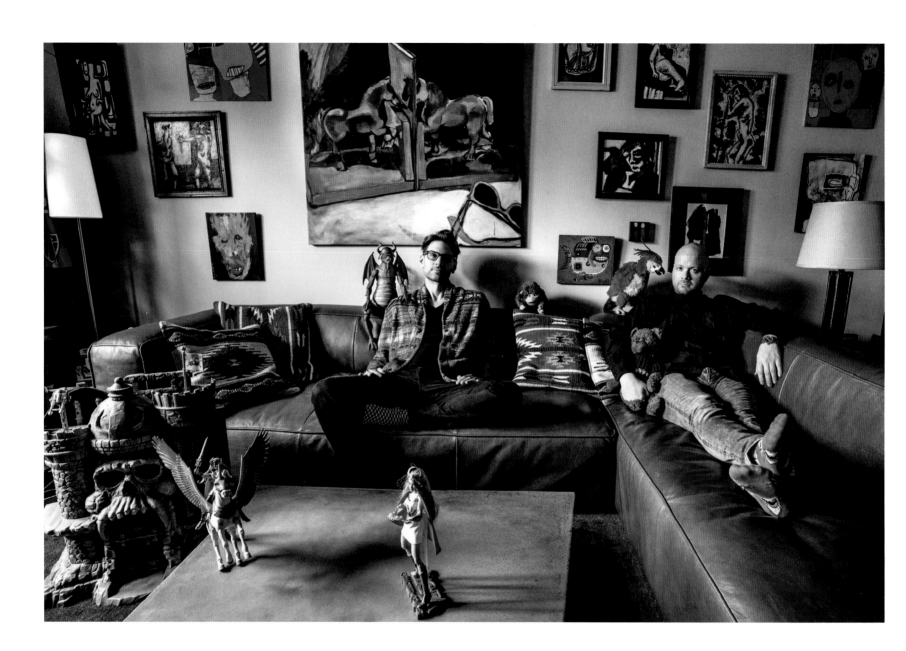

MATTHEW HITTINGER AND MICHAEL ERNEST SWEET

Photographed at their home in Queens on January 11, 2020.

Matthew was born in Bethlehem, Pennsylvania, in 1978. He was the third of four kids for Raymond and Joyce. Mom was an administrative assistant and Dad was a Lutheran minister. Matthew spent his childhood in Bethlehem and wanted to be an artist when he grew up. He collected Lego sets, toy trucks, banks, and action figures. The action figure collection, Masters of the Universe Classics, continues to this day. In school, he did very well at art and writing, but not so well at math and sports. Matthew left home in 1996 for college, eventually graduating with an MFA in writing. In 2005 he moved to New York City. He works at an investment firm and is a published poet and artist.

Michael was born in 1979 in Windsor, Nova Scotia, Canada. He was the oldest of two boys for Ernest and Catherine. Mom was a homemaker and Dad had a trucking company. He was mostly raised by his two grandmothers—one was a teacher. Michael grew up in a rural village that was named after his family home. He didn't have friends nearby, but the land and his horses were his friends. He wanted to be a policeman when he grew up, then later, a lawyer. He got good grades at school and got into a fair bit of trouble there as well. Michael left home when he headed to Halifax for college. After a year of law school, he changed his mind and went into teaching at-risk youth, a much better fit. Later, he moved to Montreal and lived there for 15 years. Michael was given a Canadian Prime Minister's Award for Teaching Excellence in 2009 and a Queen's Medal from Elizabeth II for service to education in 2011. He has published several photography books and over 100 magazine articles on art, photography, and education.

Matthew and Michael met in 2009 through *Poets & Writers* magazine and were pen pals for over a year. They got married in 2015 in New York City at City Hall and they moved into this apartment in 2017.

"I didn't realize I missed New York City until I lived on the West Coast for a bit. As I felt my creative ambition starting to slip away in sunny California, I decided to sell my car and use that money to return east and give New York a go. Many an artist has made this leap, and the one I've felt the most affinity for was Marilyn Monroe (with whom I share a birthday). I found a day job that allowed me time to work on my writing. NYC has made many things possible for me and my writing career, and I will forever be grateful for that. And though the city is always changing, its magic chased further into the shadows and corners by the proliferation of chain stores and overpriced apartments, and a population and tourist crowd too big for its infrastructure, it's still there if you choose to seek it and see it."
—Matthew

"I have a love-hate relationship with New York City, which I don't think is all that unique. Woody Allen used to say, 'New York is a great city as long as you are rich enough to get out of it.' That quote has stuck with me and that's why we travel. I love that we are at the center of the world and have so much access to so many things. I hate that other people want that too! I don't suffer fools easily and there are just too many of them in this city. Gentrification has been around since teepees and igloos. Nothing lasts forever."
—Michael

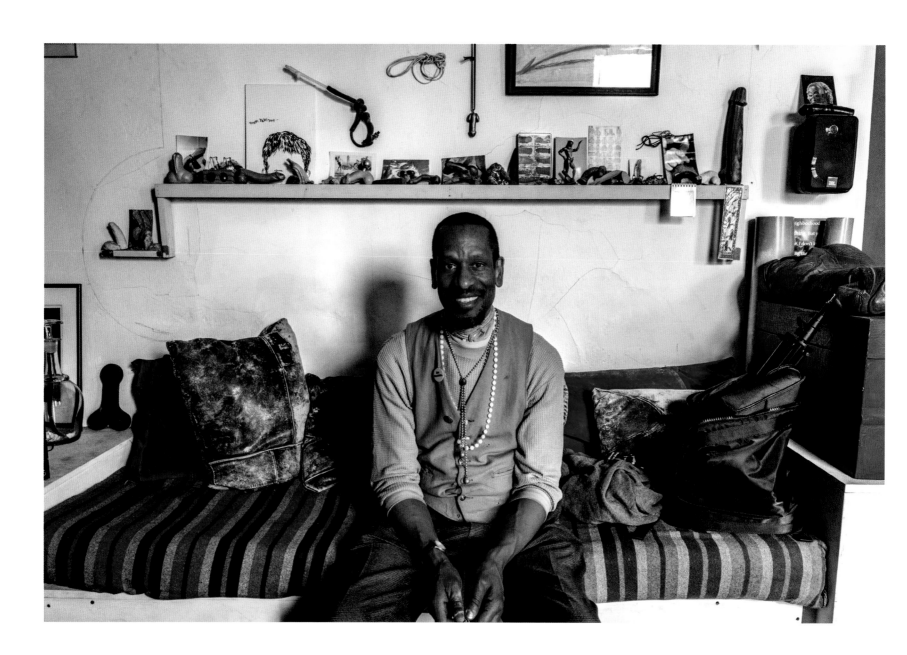

SUR RODNEY (SUR)

Photographed at his home in the East Village on April 19, 2019.

Sur was born on December 28, 1953 in Montreal, Canada. He was one of two boys. His mother was a homemaker and his father was a photographer. He moved to New York City in 1976. Sur was one of the very early founders of the East Village art scene. Sur met Gracie Mansion, the East Village art dealer, in 1978 through the artist Al Hanson. In 1984 he joined forces with Gracie and they opened the Gracie Mansion Gallery on Avenue A. In 1988 he left the gallery partnership to assist with records and archive management for friends and lovers living with AIDS. Sur met and married Geoff Hendricks in 1995. Sur writes on panels for curated exhibitions, and for institutional archives. He is a writer, artist, archivist, and activist. Sur has lived in this apartment since 1981.

"A sense of 'a community' is more difficult to find in many neighborhoods that exist today. It never use to be that way. New York City was a cosmopolitan city, where differences were expected and tolerated. Now it's been taken over by a suburban mentality, where difference has become a threat."
—Sur

BETTY TOMPKINS

Photographed at her SoHo loft on June 5, 2019.

Betty was born in Philadelphia in 1945. She was the youngest daughter for Henry and Sylvia. Mom worked as a secretary to support the family and Dad was the head of the Progressive Party in Philly. When Betty was little, the FBI would follow her to school. She studied ballet as a young girl and wanted to be Margot Fonteyn when she grew up. Betty went to college in Washington State, but in 1969 she moved back to New York to stay. She bought her loft on Prince Street in New York City's SoHo in 1974 and began her sex paintings. She met Bill Mutter, her husband, in 1975. They got married on their 37th anniversary. Bill is an artist, and Betty is a famous feminist painter now.

"I came to New York 50 years ago. I admire many things about being in the country but I can't ever imagine not being a New Yorker. I am never going to get rid of this loft."
—Betty

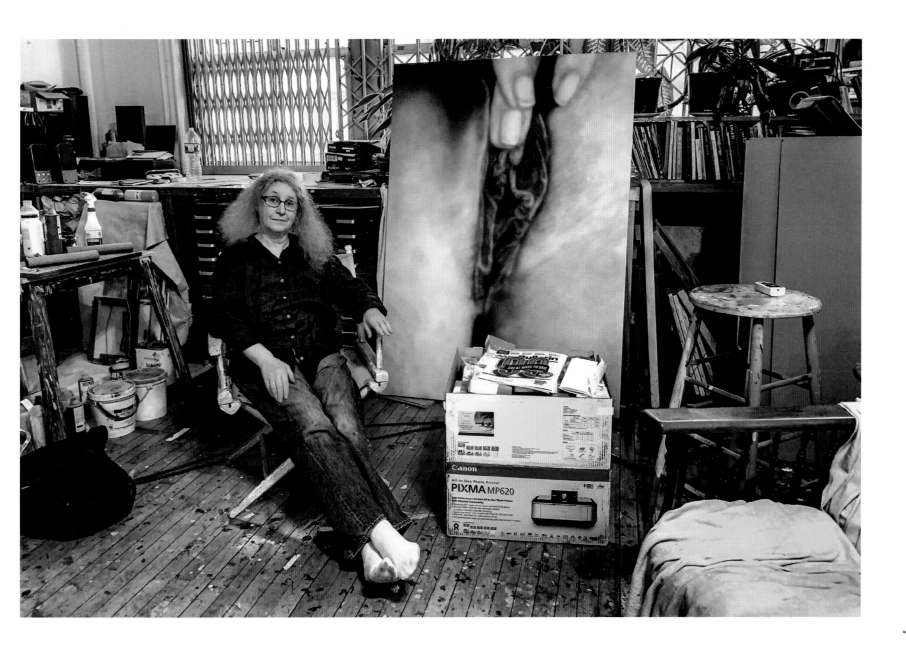

BEATRICE MORITZ

Photographed at her home on the Upper East Side on October 25, 2019.

Beatrice was born in Germany in 1960. She was the oldest of two kids for Peter and Irene. Peter was in the Hitler Youth in Germany when he was ten and Irene was in France on the run from the Nazis when she was ten. Peter's dad was a Nazi pilot and Irene's dad perished in Auschwitz. Peter and Irene met and married after the war ended. Bea's surviving grandmother and her two sisters ran the family business: a horseback riding school. She remembers her German childhood as a magical one, growing up near the stables in a beautiful house built by a famous architect. Her dad fell in love with America on a business trip, and when Beatrice was eight years old they moved to Florida. Following a brief initial stop there, they settled in Connecticut. Bea lived in Connecticut until she finished college, then moved to New York City in 1983. She worked as a fit model and as a singer/songwriter. Then she learned to be a legal proofreader. Bea joined a proofreading agency where the boss came to work in drag every day. He also required all male employees to do the same, and would sometimes include naked photos of himself in their paycheck envelopes. He was charismatic and paid very well, so most people stayed on. Beatrice also worked as an appraiser at Sotheby's and as a silver dealer, before she started her life as a political photographer in 2003. Beatrice has gone on to photograph presidents and world leaders.

"With my upbringing and mixed background, it took me a long time to feel American. I never really knew if I was German, French, or American. Moving here opened my eyes to what my people did in World War II; I was wracked with guilt for years. My parents' marriage in the '50s was quite controversial. Both sides of the family were against the union as the war had only ended 12 years prior. It made for some weird dynamics; it was as though the war continued to be played out in some ways in my parents' oil-and-water relationship. New York City is truly a miraculous place. Every single block is different from the next; every neighborhood has its own unique vibe. My philosophy is this: find quiet places to spend time in—the park, your apartment, museums. Life can be pretty fast-paced here—it's good to slow down and enjoy a quiet day at least once a week."
—Beatrice

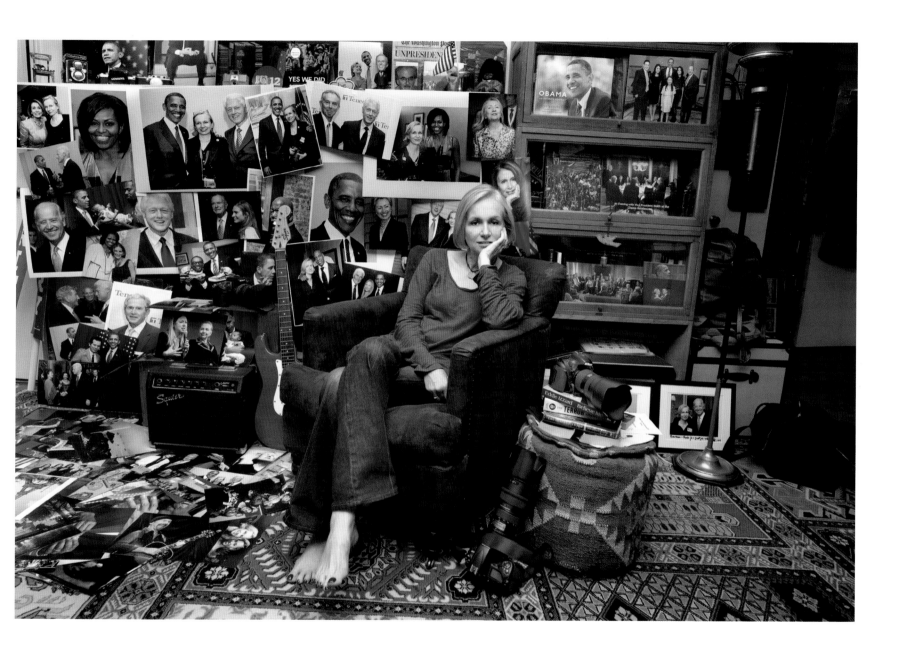

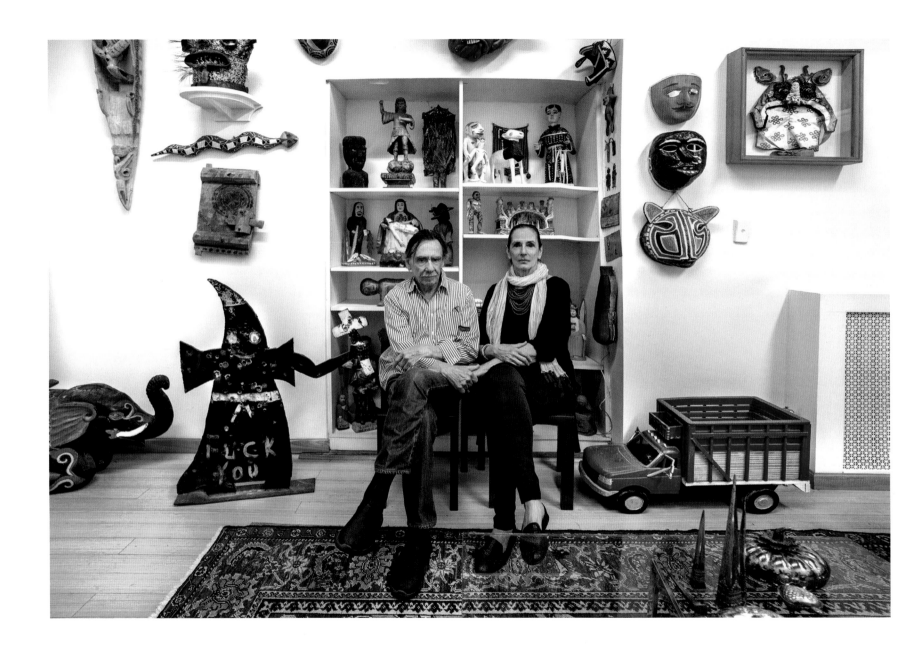

ED McGOWAN AND CLAUDIA DeMONTE

Photographed at home in SoHo on October 14, 2019.

Ed was born in 1938 in Hattiesburg, Mississippi. He was the oldest of two children for Ed and Emily. Dad was a lawyer and Mom was a secretary. Ed spent his childhood in the South. He wanted to be the Heavyweight Boxing Champion when he grew up. Ed was an average student, excelling mostly at daydreaming. He took dance classes, played sports, and belonged to social clubs. In 1958 he left home and went off to college: first, a year of engineering, and then five years of art. He was way better at the art. Ed worked at a gravel pit, as a store window dresser, at a city engineer office, at a Congressman's office at the Pentagon, and as a bootlegger. Ed got married, had two kids, was the Mississippi Golden Glove Champ twice, got divorced, and moved around a fair bit before moving to DC in 1968 to teach sculpture. He met Claudia there in 1973, and in 1976 they moved back to New York City together. Ed has shown his art at the Whitney Annual and other important galleries.

Claudia was born in 1947 in Queens, New York, the oldest of two girls for Ammeda and Joseph. Dad was an insurance broker and Mom was on the community board. Both were Democrats and community activists. Claudia spent her childhood as the tallest girl in Queens. What she wanted to be when she grew up evolved as she went through the years: first, wanting to be a nun, then finally settling on being an artist when she was 20. She belonged to the bowling club and the Italian club, volunteered at the local hospital, and sold lampshades at Bloomingdale's. Claudia moved away to college in 1965, ending up in Washington, DC, for grad school. Her and Ed met there in 1973, and in 1976 they moved back to New York City, where they still live. Claudia taught art for 32 years and her art is in museums and galleries everywhere.

Ed and Claudia met in DC in 1973. Three years later, they moved back to New York and got married shortly thereafter. In 1979 they moved into this loft and they live there still.

"New York is wonderful if you can stay young. As an immigrant from the South I have never regretted being in New York, but still, more than 40 years later, I do not really know my way around. I accept that it is me, not New York that creates this condition. Fortunately, I have Claudia who is totally fluent in 'New York.'"
—*Ed*

"I'm a native New Yorker, I love this city. I'm energized by it, just by walking down the street. Like most kids in the boroughs at the time, I called Manhattan 'The City.' I was raised by enlightened parents, who had to work hard for everything they had, but who also told us we had a responsibility to help others. Unusual at the time of Archie Bunker, they also respected all in my ethnically diverse Astoria. We grew up in a household filled with diverse people of every religion, race, and socioeconomic mix."
—*Claudia*

GERALD DeCOCK

Photographed at home in the Chelsea Hotel on November 26, 2019.

Gerald was born in 1958 in Kansas City, Missouri. He was the seventh of 11 children for John and Kitty. John was a tariff manager for truckers and Mom was an administrative assistant at a concrete company. When he was six years old they moved to Denver, Colorado, where he spent his childhood, ten minutes from the mountains. Gerald wanted to be an actor when he grew up, and has done some acting in recent years. He wasn't a great student, but loved to ski. Gerald had a paper route, worked at a carwash, was a dishwasher at restaurants, and worked at a greenhouse. He studied cosmetology when he was still in high school and that is one of the things he does to this day, in addition to being a hairdresser. He left home when he was 17, and moved to Manhattan in 1984. Gerald has lived in this apartment since 1994.

"New York is magic to me. Gentrification is inevitable. You can choose to resist it or live your privileged life and be grateful for what you have. I choose to focus on how incredibly blessed I've been in this life. I live in a famous landmark building that's been under construction for eight years. It's complicated, but my takeaway is this: if the building is a living thing and the ghosts are resisting the transition, I have no idea what will happen, but I live joy every day in my magical abode. I choose not to be angry about it and be in the present always."
—Gerald

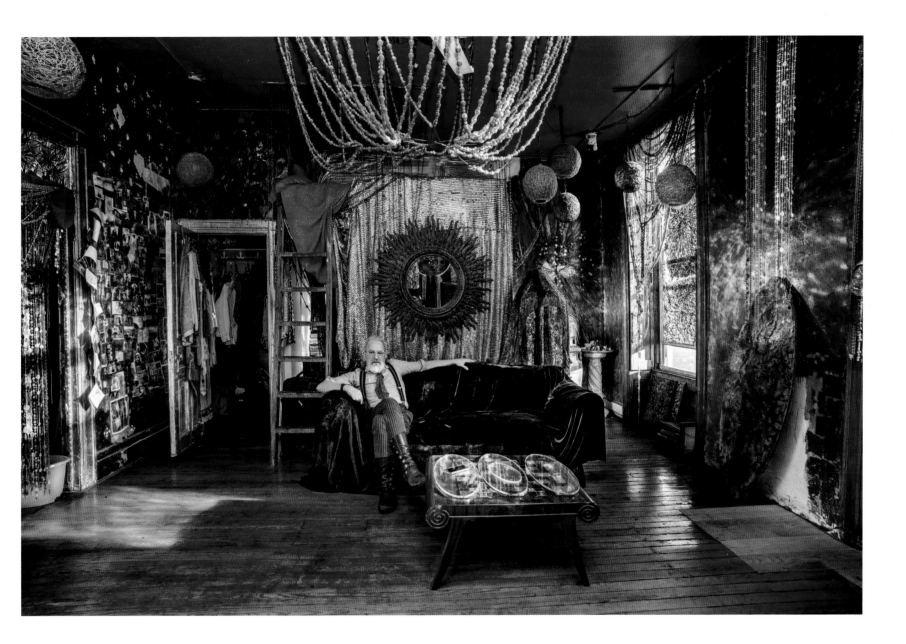

LINDA HEIDINGER

Photographed at home in the East Village on January 27, 2020.

Linda was born in San Jose, California, in 1947. She was the second of three kids for Eddie and Edna. Dad worked at Westinghouse and Mom was a hairdresser. Linda spent her childhood in Sunnyvale, California, one block away from the shopping plaza. She was a good student, especially at theater and art class. She wanted to play golf when she grew up, or be a comedian. When Linda was 17, she left home and joined a convent. She lasted as a nun for six years before she changed her mind and returned to the free world. She graduated college with a degree in painting, and in 1981 hit the road, bound for New York City. There, she waited tables, cleaned apartments, was a switchboard operator in the World Trade Center, and was an art coordinator at a hospital. Eventually, Linda became an owner of a restaurant in the East Village. It was called The Pharmacy because it used to be a drugstore. It was one of only two places in those early, scary days that you could take your Mom to eat. If you could make it there without getting mugged, you could count on a fun, enjoyable evening with good food and music. It was also ground zero for all the neighborhood art opening parties. A couple of years later, Linda opened Alphabets gift shop just down the street. It became a shopping destination right away, for all kinds of groovy New Yorkers, in spite of the neighborhood's dangerous reputation. Linda has lived in the East Village for 40 years.

"As early as I can remember I was drawn to New York City. I always knew it was the right place for me, and as soon as I arrived I felt immediately plugged in. For 40 years, the East Village has been my home and workplace. I love its rich history of immigration, protests, and rebellions, drag festivals, artists, musicians, and writers. When I arrived in 1981 my neighborhood was a wild and fringe area. But everything changes, especially in NYC. Today, there are hundreds of vacant storefronts, posh cocktail lounges, hip restaurants, and loads of new high-rise, luxury condominiums. I am still happy to be walking these streets everyday, feeling the vitality and energy of what I still consider to be the best neighborhood in New York City."
—Linda

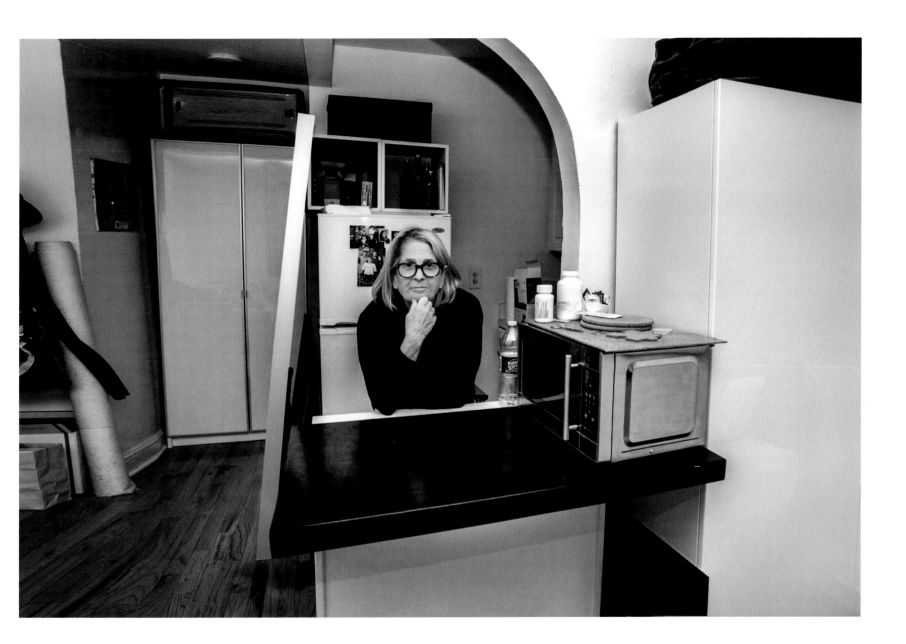

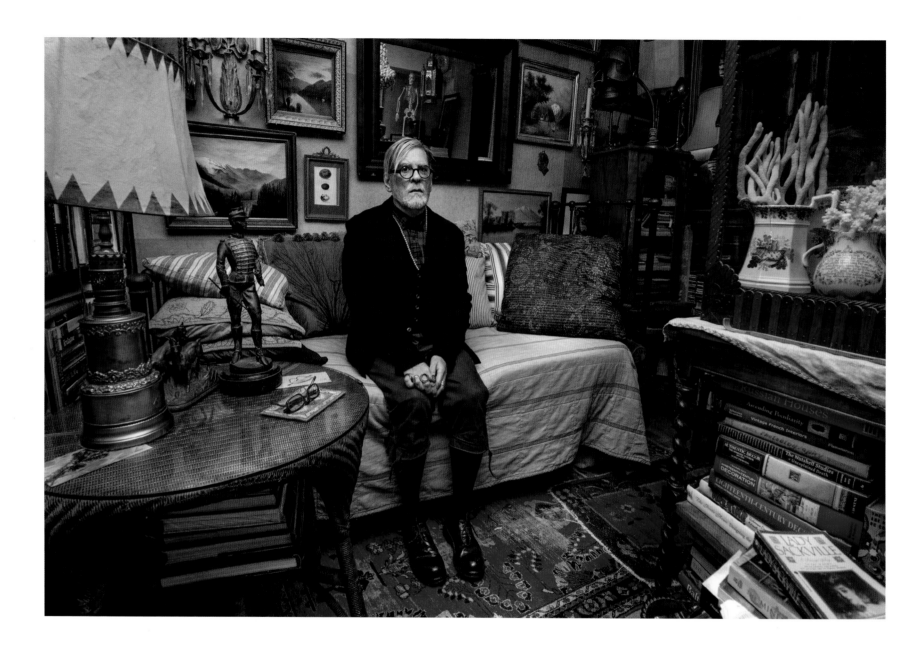

JAMES KASTON

Photographed at his home in Stuyvesant Town on November 2, 2019.

James was born in 1957 in Manhattan, the youngest of two boys for Gene and Peggy. Mom was a schoolteacher and Dad was a graphic artist. James spent his childhood in Queens and Long Island. He was an OK student, who wanted to be an actor when he grew up. He went to antique auctions with his grandmother and ended up in the antique business later on. He studied art at college and then moved back to Manhattan in 1980. James had a paper route, shoplifted to pass the time, and collected comic books as a kid. Later on, he was a gardener, although plants died quickly under his care. He worked for the highways department, did retail at Lord & Taylor, and worked doing layout simultaneously at an Orthodox Jewish ad agency and at a gay magazine. Now, he does stand-up monologues. He moved into Stuyvesant Town in 1982 and lives in this apartment with his partner Kim.

"I still like New York City, but not the bike lane, not the bikes, not the people on the bikes. I don't like the glass towers and I don't like all the chain stores in this city. It's really become a city of greed. I don't like the way the word 'luxury' is tossed around regarding things that should just be described as 'plain.'"
—James

CHARLENE McPHERSON

Photographed in her Gramercy Park apartment on January 3, 2019.

Charlene was born in 1974 in Medina, New York. She was the youngest of two for Duane and Rebecca. Mom and Dad were both factory workers. Charlene grew up in a two-bedroom apartment on a dead-end road in Medina. She wanted to be a Broadway singer when she grew up. She was also a baton twirler in the school's marching band and took dance classes. She did really well in her rural school at all things music, but Charlene skipped school often. She learned how to fight early on and spent a lot of time in detention. Charlene left home when she was 17, moved to Houston, Texas, and got a job as a nanny. Eventually, she moved to New York City. She moved in and out a few times, struggling with the high rents, but finally settled here in 1999. Charlene worked as a live-in servant on the Upper East Side. She polished the lady's silver and prepared the food for her once-a-month dinner parties for New York City's famous literary types. She lasted about a year, but bedbugs and "the lady's crazy" drove her out the door. Following that, she worked as a "booker" for an Upper West Side "escort service." There was a Rolodex, some very famous men, and lots of rules on where to send and not send the girls. Finally, growing weary of men paying for sex, Charlene moved on after a year. In 2000 she met Mo Goldner, a guitar player, and in 2004 she married him. Charlene and Mo started a band and called it Spanking Charlene. Their third record debuted on Valentine's Day, 2020. Charlene sings in the band and works as a house manager for a tech CEO. They moved into this apartment in 2006 and live there still.

"I love living here, but as time goes on and I get older, I wonder if this is where I want to be as an elderly person. I find myself thinking, 'This city is for young people.' At 45 years old, I don't feel as 'seen' as I once did. How can that even feel at 55? For now, it's OK. I'm OK. I see the gentrification and it's sad. So much that is interesting and different has been pushed so far out. Some days Manhattan feels like a suburb, but I have to believe that people like me all sat in front of their TVs as kids. We watched the parades and all the exciting New York things from our teeny-tiny towns. We were drawn here because we were different. We wanted to go to a bigger place where we could be anyone we wanted to be. It wasn't necessarily bad that we were different, we just knew we weren't like where we came from. New York City has to be still calling those people. The real question is, are they able to find a place for themselves here? I do believe NYC is still calling and young people are gonna still keep coming. Hopefully!"
—Charlene

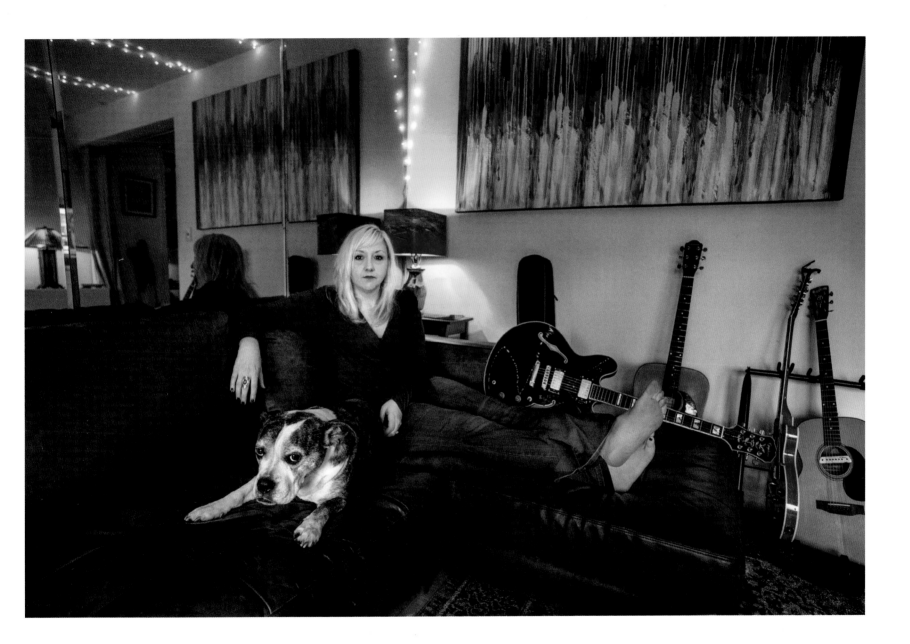

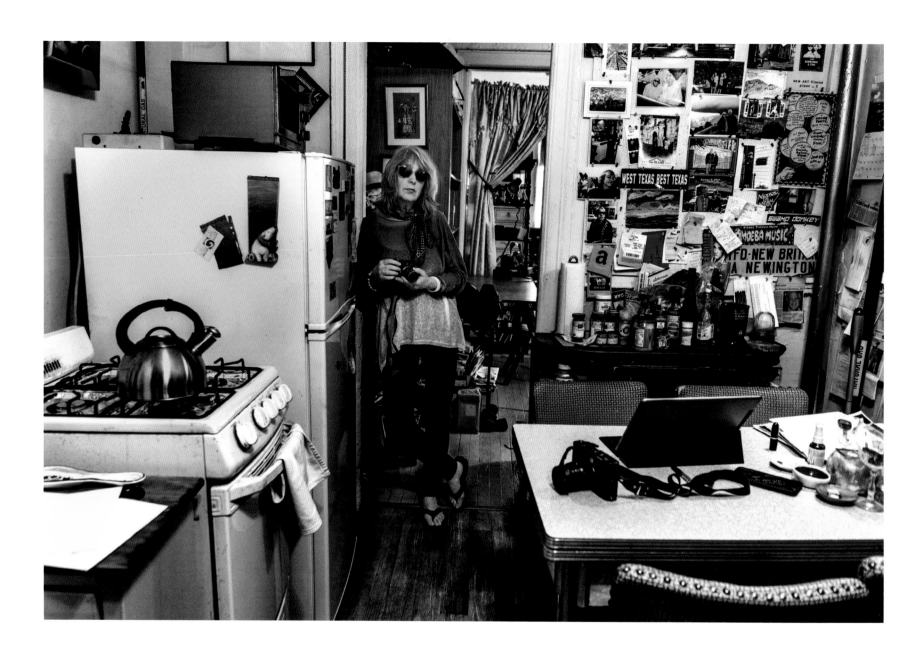

LYNNE BURNS

Photographed at her home in the East Village on May 7, 2019.

Lynne was born Lynne Kveselis in 1951 in New Britain, Connecticut—the Hardware City of the World. She was the middle child to John and Alda. Mom worked and Dad was in the Air Force. Lynne heard Bob Dylan in Grade 10 and that changed her life forever. It was the '60s and she started taking the two-hour train ride into New York City, hanging out in Greenwich Village. After college, Lynne moved to Cape Cod for a while, then moved to New York City. She worked as a librarian on the 82nd floor of the World Trade Center during the day and went to CBGBs at night. In 1978 she leased this apartment for $160 a month. Lynne became a photographer, waitressed, traveled the world, and married Buster Atkins. Together, they ran a gallery store in the East Village. They still live in this apartment.

"I love New York City. Yes, there are changes I don't like. But each generation falls in love with their own version of it. My lifestyle allows me the freedom to leave the city. Sometimes I have the ocean, sometimes the mountains. And many times I see two off-Broadway shows a week. My advice to the next generation is never get an apartment above the second floor. You might end up living in it for the next 40 years."
—Lynne

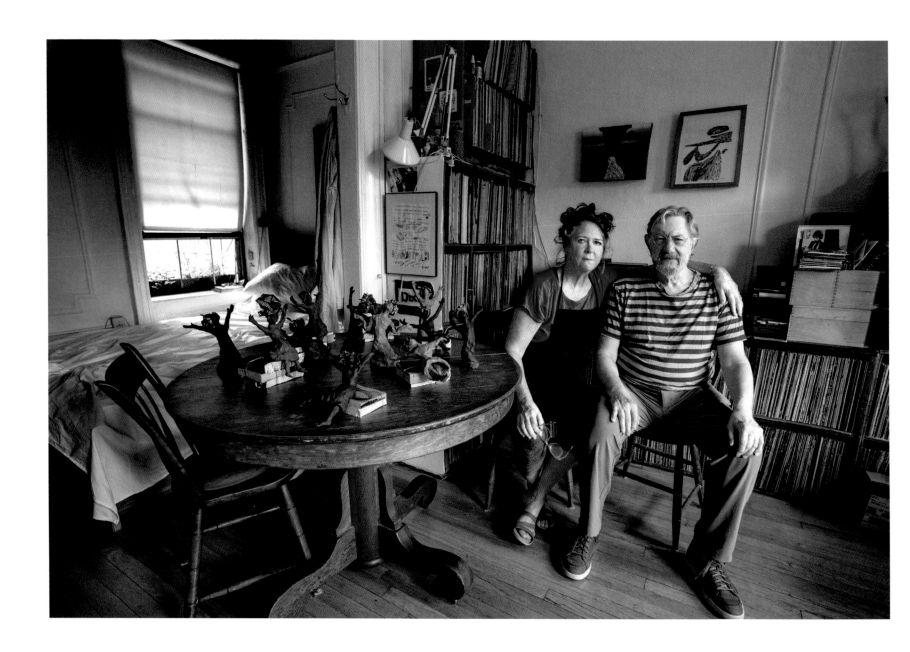

ANGELA FREMONT AND HAROLD APPEL

Photographed at their home on Stuyvesant Street on June 29, 2019.

Angie Freemont was born in rural Miami in 1951, the oldest of three girls to Toby and Ginger. Toby was a traveling salesman, who built boats and drank a bit too much, and Ginger was an easel painter. Dad was away six months out of the year and Ginger wasn't very nice to the kids. Angie spent her youth running barefoot through the Florida scrub and riding her bike behind the truck that sprayed DDT to kill mosquitoes. She once saw a matchbook cover, with a profile of a pretty girl on it, that said, "If you can draw this, you can have a career as an artist." Angie knew she could draw that girl. Narrowly escaping death from an illegal abortion in Birmingham, Alabama, in 1969, she hit the road. In June 1970, in a green 1964 Volkswagon, Angie packed a hammock, a sleeping bag, a box of crackers, some peanut butter, $200, her guitar, and a dog named Honey, and headed north. She waitressed, pumped gas, and sold cigarettes. Angie was a really fast typer, and finally got a job as a secretary and returned to art school in Manhattan. She moved into this apartment in 1977 and is still an artist.

Harold was born at the New York Doctors Hospital in 1942, the oldest of two boys for Charles and Sylvia. Mom and Dad were both from New York City and were both lawyers. Harold lived over his grandfather's Lower East Side store on Grand Street until he was six years old, then they moved to a new housing development in Queens. Harold wanted to be a cowboy when he grew up. He got his first apartment in 1964 on 22nd Street, when he was going to medical school. It had a shower in the kitchen and the toilet was in a closet. Before Harold became a neurologist, he worked as a security guard at the World's Fair, at a day camp for five days, and had a very brief career as a paper boy. Harold also served in the navy, getting discharged as a conscientious objector in 1971.

Angie met Harold, the doctor, somewhere around 1979. Four years later, they got married at St. Mark's Church, across the street from her place. Harold moved into the apartment and they raised their two kids Spike and Dixie there. The kids have grown and moved out, and Angie and Harold live there still.

"I love being a New Yorker. I think we are all neighbors here. It's important to me to greet people in the street, talk to my cab drivers, cashiers, salespersons—anyone walking down the street with me. I remember after September 11, I would ask people, 'Can I walk with you?' and I would take their arm. No one ever said no. We would talk. I would feel safer. And the city became more intimate again. I will never leave New York. It really is my home."
—Angela

"I can't imagine living anywhere else. I still love New York City, in spite of its contamination by chain stores and gentrification. A city of many small towns. Stuyvesant Street is the best street in NYC, maybe the world. The only true east-west street in Manhattan. It was an Indian trail, I think. I live across the street from where I was married 35 years ago. I love being retired and able to wander around and say hello to people in the neighborhood. When I go to B&H Dairy, Michael gives me my breakfast without asking what I want—he remembers even after six months—and calls me Papa."
—Harold

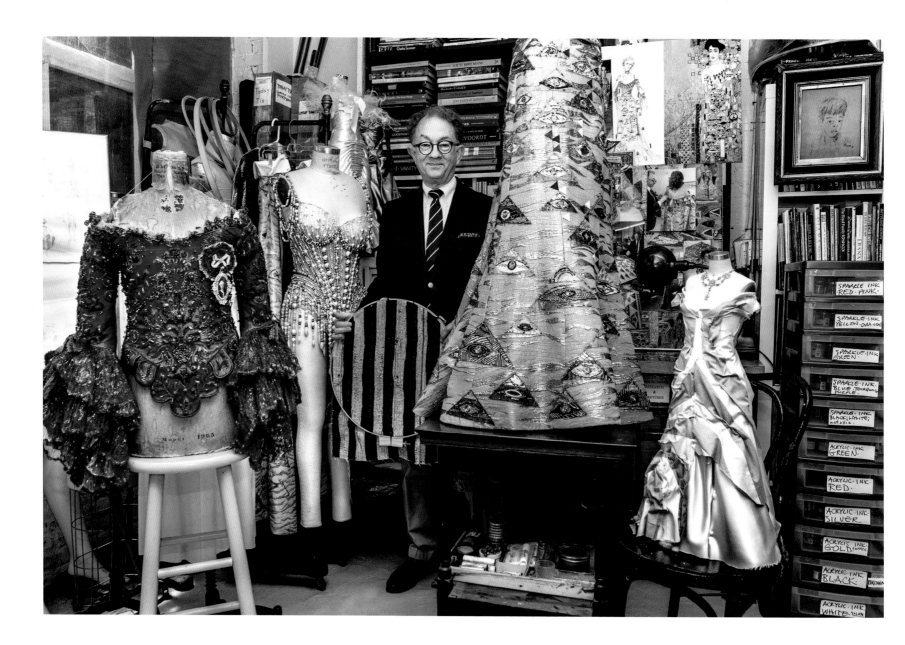

WILLIAM IVEY LONG

Photographed at his Tribeca studio on May 22, 2019.

William was born in Raleigh, North Carolina, in 1947. He was the first of three kids for William and Mary. Dad was a professor and stage director, and Mom was a high school theater teacher, actress, and playwright. He spent his childhood in the Carolinas and wanted to be an architect when he grew up. He built little houses and little cities at the roots of trees. William loved and excelled at school, and spent his weekends drawing and painting. Later on, he went to Yale Drama School and studied set design under designer Ming Cho Lee. William met some future movie stars there and in 1975, after Yale, he movedto New York City. He moved into the Chelsea Hotel in 1975 and lived there for five years, throwing some great parties there. He went on interviews, to no avail, but gave great parties at the Chelsea. William worked as an apprentice to couturier Charles James and after three years he left to develop his own costume designs. He has designed for over 60 Broadway shows, has won six Tony Awards, and has been inducted into the American Theater Hall of Fame. William has been in this studio since 2010.

"I moved to New York City and into the Chelsea Hotel to be 'where it's at.' It was the right choice."
—William

GRACIE MANSION

Photographed at her home on the Upper West Side on October 3, 2019.

Gracie was born Joanne Mayhew in Pittsburgh in 1949. She was the second and last child for Fred and Helen. Fred was a salesman and Helen was a secretary. The family moved around a lot, mostly staying in Pennsylvania. Joanne was a smart kid and did really well at school. She wanted to be a librarian when she grew up, working all kinds of jobs along the way. She sold doggies in a basket on the boardwalk at Atlantic City, did graphic design, was a typesetter, a painter, a secretary, a saleswoman in a clothing store, made jewelry, and was a director at a print gallery. Like most rebels in the late '60s, Joanne hitchhiked around a bit and did some time at college, too. She also lived in a New Jersey commune, before moving to Manhattan's East Village in 1980. Reconnecting there with her friend Sur Rodney (Sur), her life as an art dealer began. Together, they put on shows here and there, once selling work from a limo they parked near Leo Castelli's gallery, hoping to get his attention. It was a very important time in art history. All things seemed possible and the East Village was ground zero for the new scene. Joanne changed her name to Gracie Mansion and held an exhibition in her tiny apartment bathroom. It was the beginning of a long, famous career in the art business. Gracie lived in the East Village for 39 years, until 2019 when her dining room ceiling collapsed and she had to move. Unable to find an apartment in the East Village, due to gentrification's high rents, she had no choice but to leave the neighborhood and move to Manhattan's Upper West Side.

"I came to the East Village in 1980 and became part of the stew of artists, drug dealers, and Ukrainians. It was a dangerous time, but there was an embracing artistic buzz. Everything seemed not only possible, but probable. It was Paris between the wars. Then AIDS hit and we lost our soul. The art world changed to the 'art market.' Rents soared, but against all odds, art persists. We have the best of the best and lots of it. It's a gift to live here among it."
—Gracie

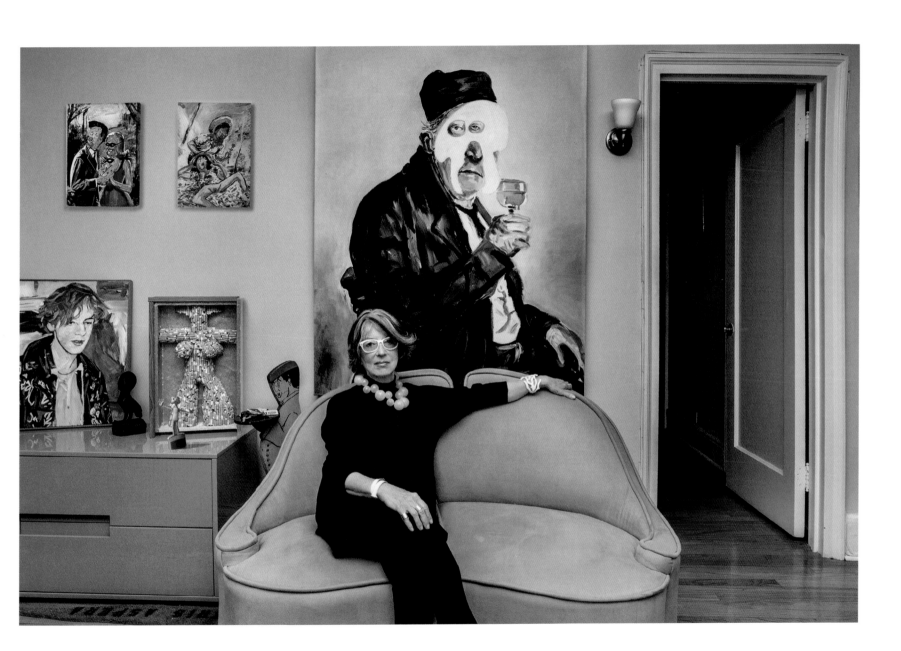

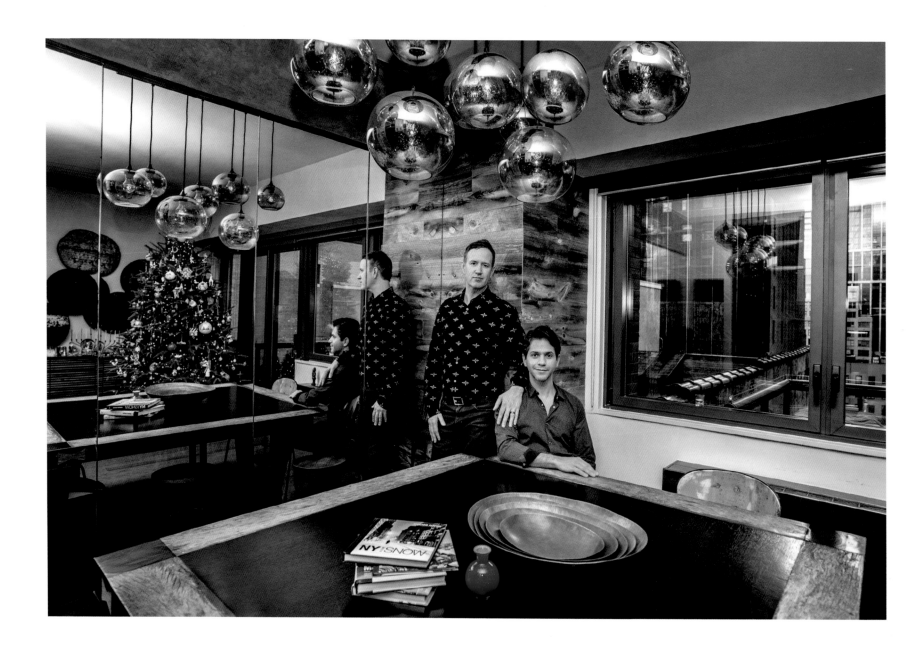

BENNY HANSEN AND MALAN LIBÓRIO DOS REIS

Photographed at their home on West 58th Street on December 15, 2019.

Benny was born a Mormon in 1979 in Ogden, Utah. He was the fourth of six kids for Douglas and Linda. Dad worked for Mitsubishi and Mom ran the household. He spent his childhood in Sandy, Utah, and wanted to be a talk show host when he grew up. He was always in trouble for talking too much at school. Benny spent his school years in theater and ballroom dancing. His parents signed him up for soccer, basketball, and golf, but not one of those things lasted more than a season. A square peg in a round hole type thing. After high school Benny spent two years in Warsaw, Poland, as a Mormon missionary, but in 2005 he officially left the Mormon Church. After returning from Poland he graduated from college. He worked for an airline company, traveling to over 15 countries, getting "beautifully lost," and then for a furniture company that totally changed his career path. In 2008 he followed his heart... all the way to New York City.

Malan was born in Petrolina, Brazil, in 1980. He was the third of four kids for Maria and Malan. Mom worked for the government and Dad was an accountant. Both sides of Malan's family come from a long line of farmers that grew beans, melons, mangos, and coconuts. He grew up and spent most of his childhood on his grandfather's farm in rural Bahia, swimming whenever possible. He wanted to be a veterinarian when he grew up. He studied computer science at college, but didn't discover his true creative calling until he moved to the US in 2002. He apprenticed with a designer in New York City and mastered the fine art of decorative finishing.

Benny and Malan married in 2013 and they have lived in this West 58th Street apartment since 2015.

"I met my husband on 80th and Lexington, crossing the street one early morning almost ten years ago, when I was working at the Metropolitan Museum of Art. For that reason alone, I tend to have very deep feelings for this city and its endless giving. I have a romance with New York City that fluctuates between insatiable lust and old-age, rocking-chair handholding. What irritates me most about living here is the brainwashed mentality of sizing up every other city to its ferocious culture and sparkle. I will die here, this much I know. And I would like to see the grit seep back into all the neighborhoods, that seems to have been overly mopped up during these radical gentrification sweeps. As far as Manhattan goes, it feels like the grit is hiding out on the Lower East Side. Parts of New York City I fantasized about as a kid still live down there."
—Benny

"Everything is possible, every minute of every day. Before living in New York City you have a consciousness of the difference between a weekday and the weekend. When you live in New York City there is no distinction and the seven days and nights behave the same. I like that being gay is ordinary in New York City. Where I come from, walking down the street, holding my husband's hand would be very dangerous, so I guess that aspect of being ordinary is beautiful. My real issue with this city is its filth. I've never quite accepted it. It can be very loud too, but then again, so is my husband. Many people have different thoughts on gentrification, and I just see that things got cleaner and safer. Artists and the people that brought New York City to life being able to afford to hold onto their neighborhoods is another story, and one that bothers me."
—Malan

IRIS ROSE

Photographed at her home in the East Village on June 25, 2019.

Iris Rose was born in 1953 in Long Beach, California, the youngest of two kids for Les and Jean. Dad was an engineer on the port and Mom was a high school choir teacher. When they got a divorce, Mom married one of Iris's college professors. Iris spent her youth watching TV, lip-syncing to records, and drawing paper doll clothes. In sixth grade she decided she wanted to be an actress when she grew up. After college she founded two theater groups, was in a band, and was a performance artist. She moved to New York City in 1982, and soon after she met and married James. They moved into this East Village building, The Mildred, in 1983. At the time it was only one of three buildings still standing on her derelict block. That's how it was back then in the East Village. A year later they had a son and he grew up in The Mildred. James and Iris got a divorce, but Iris Rose still lives there. She worked as a street vendor, bookkeeper, housekeeper, art teacher, office worker, sewing teacher, singer, and sewer of children's clothes. She collects Pez.

"I never intended to stay here forever, but I never had much money and my rent-stabilized apartment was and is my lifeline. Ever since my son was five, I have rented out one of my bedrooms to some lucky artist or student, so my rent is very low. But my apartment is far from modern. I have no shower, no air conditioning, no microwave, and no elevator. Everything is crooked, cracked, bumpy, and hard to keep clean. But I have space, light, cross ventilation, and plenty of heat and hot water. I will stay at the Mildred as long as I can climb the stairs."
—Iris

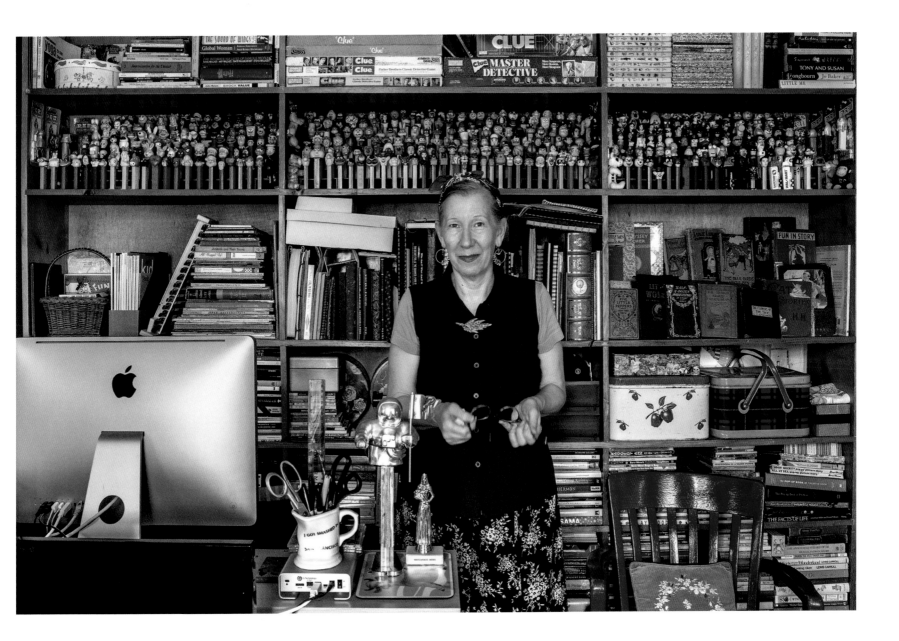

MATT WEBER

Photographed at his home on Manhattan's Upper West Side on October 17, 2019.

Matt was born in New York City in 1958. He was one of two boys for Sybille and Fritz. Mom was a playwright and Dad was a pool shark. Dad met his maker when Matt was still a little boy. Mom married Tony and together they raised up Matt and his brother. Matt spent his childhood on the Upper West Side. He wanted to be a New York Yankee until he was 11, then he wanted to be an outlaw like Peter Fonda in *Easy Rider*. Matt was good at art when he was a kid and spent a few years decorating the trains with graffiti, as was the rebel art culture back then. He worked in a bookstore, dabbled in the construction business, and then in 1978 he started driving a taxi. Matt bought a camera and photographed the city as he drove his cab, resulting in one of the best collections anywhere, hands down, of New York City back in the day. He was married just long enough to bring his daughter Elizabeth into the world. Matt moved into this apartment in 2008 and continues to photograph.

"I stay here because I am really just a city boy and I actually like the subways and Coney Island. Many people loved the gritty and dangerous 'Old New York.' And I did too, until I had a daughter."
—Matt

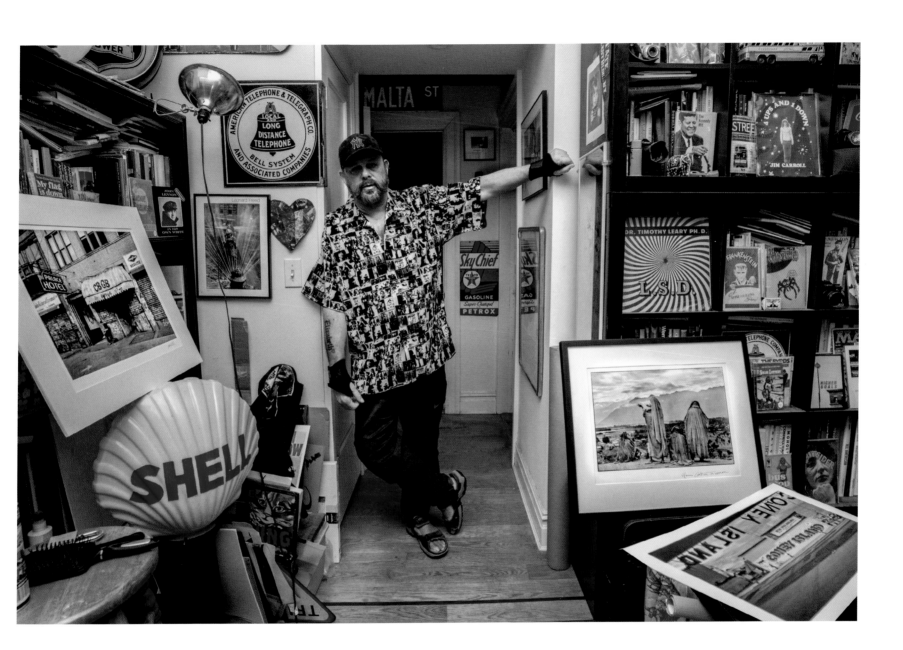

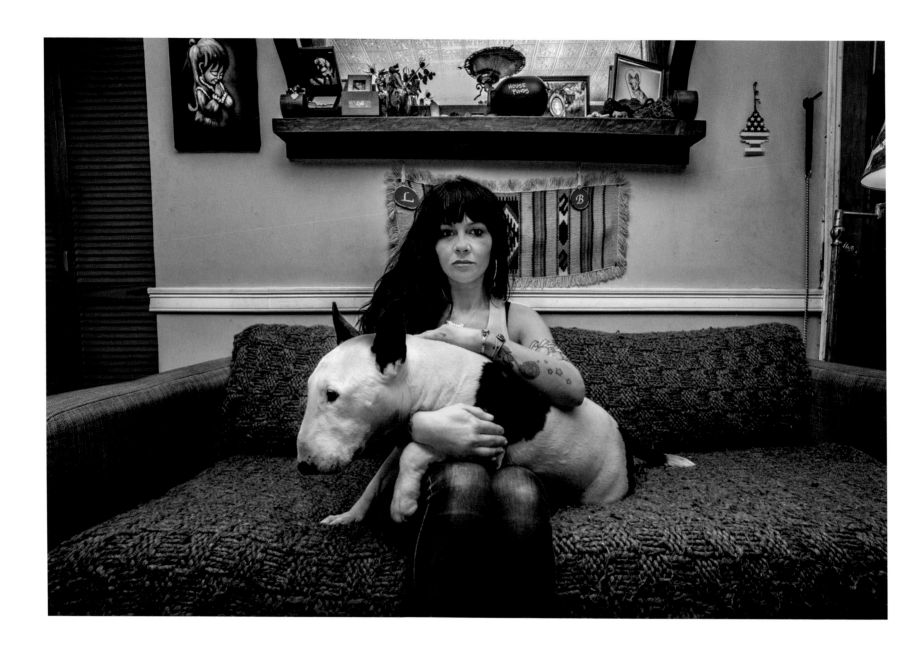

CRESSA TURNER

Photographed with her dog Buckaroo at her home in Brooklyn on November 5, 2019.

Cressa was born in Eatonville, Washington, in 1978 and was the oldest of three. She was raised by her mom Lisa and her stepdad, and spent her childhood in Tacoma, Washington. Cressa was a very happy and outgoing little girl, who did well at most things. She wanted to be a professional bowler when she grew up. At 16 years old, Cressa left a bad situation with her stepdad behind and moved in with her grandfather, who she adored. She was a cheerleader and a gymnast. She finished high school and pretty soon after that moved to Seattle, the Grunge Capital of the USA. There she found her people: stoners, musicians, and artists. It was a fun time. She ran a record store and worked in coffee shops, until finally she signed up for beauty school and learned to cut hair. Hair has been saving her life ever since. In 2006 she moved to Brooklyn, New York City. She has lived in this apartment since 2013.

"Brooklyn is absolutely home to me. I have never felt so at home as I do here. Hair is my absolute life. I live, eat, and breathe hair. What I love about living in New York the most is the wide variety of clients I have: presidents and founders of companies that are legendary; artists—famous and not famous (although they should be); lawyers; finance; and the mamas! Mad respect to all my mamas out there. I love that all of us black sheep keep the NYC hustle alive and well, even as all of our legendary institutions disappear and are replaced by the mundane, vanilla gentrifications and high rises. I always say, 'I'm happy I don't have to watch my back at the ATM anymore, but some sort of middle ground would be ideal.' However, that's not the world we live in, and I'm not mad at gentrification—it's how I make my money! If there were only a way to strike the right balance. The squares wouldn't be anything without all of us."
—Cressa

GILLIAN McCAIN AND JIM MARSHALL

Photographed with their dog Barkley at their Chelsea home on December 16, 2019.

Gillian was born in 1966 in New Brunswick, Canada. She was the youngest of five kids for Harrison and Billie. Mom was a homemaker and Dad was in the food business. Gillian spent her childhood years in New Brunswick and wanted to be a writer when she grew up. She excelled at English and did "not so great" at math. She did competitive swimming, basketball, volleyball, and did after-school theater too. She worked as a cheesecake caterer and worked in the office of a lobster exporter. Gillian studied English literature at college and moved to Halifax for three years, before moving to Manhattan in 1987. She collects "found" photographs, has published two books of poetry, and wrote and published *Please Kill Me* with Legs McNeil. The book spans the early-punk period of the Velvet Underground, through the rise and fall of punk icons Iggy Pop, the Ramones, and more. Gillian was the chair of the board of directors of The Poetry Project at St. Mark's Church in New York City.

Jim Marshall was born in 1959 in Paterson, New Jersey. He was the youngest of two boys for Marilyn and Tony. Marilyn was a loan shark and Tony might have been one, too, but Jim didn't meet his father until he was 19. Jim spent the first eight years of his life in Paterson and then moved to Florida, living there until he was 18. When he was in high school he played football, wrestled, and boxed. He wanted to be a writer when he grew up. He left home at 15 and started writing for music magazines. He lived with a 22-year-old prostitute for about a year and bounced around cheap hotels. The day he turned 18, he moved to Manhattan. He was a vault worker, a bouncer, a bartender, a DJ, a music editor, a columnist, a "bike messenger," worked in construction, and emptied parking meters for one day. Jim, also known as "The Hound," had his own radio show for 12 years and was an owner of the legendary Lakeside Lounge in the East Village until 2013.

Gillian and Jim met at the St. Mark's Church Poetry Project and started dating in 1996. They married in 2003 and have lived in this house since 2004.

"From the first time I visited Manhattan in 1977 I knew that this was home. And as much as New York has changed over the years, which has broken my heart, it is still home, and still the greatest city in the world. I cannot imagine not living here. Before I got married, immigration was a nightmare, but I always managed to get visas through jobs, which sometimes wasn't easy. I've been here for more than half my life, but when I go back to Canada, people still ask me, 'So, are you still living in New York?'"
—Gillian

"New York City used to be a great, wide-open city where you could live like a millionaire on nothing if you knew what you were doing. Those days are long gone."
—Jim

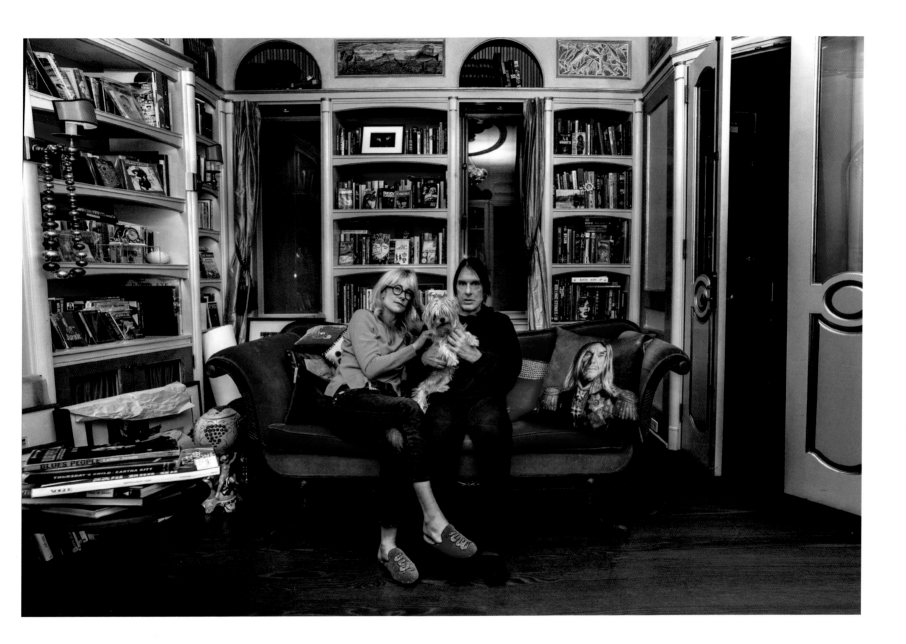

DANNY FIELDS

Photographed at his West Village home on April 23, 2019.

Danny Fields was born in 1939 in Brooklyn. He was the oldest of two boys for Harry and Sylvia. Mom was a homemaker and Dad was a doctor. He spent his childhood in Queens and summered in rural New Jersey. Although he had no idea what he wanted to be when he grew up, and claims to still not know, Danny was super smart at school. He "excelled at things that benefited from amphetamine-enhanced memory." He left home for good at 16 and he didn't learn to catch or throw a ball until 2019. After stints at three colleges, including Harvard Law School, he moved to Manhattan's Greenwich Village in 1960, where he "sort of" got a master's degree in English literature at NYU. Danny sold books at Doubleday, worked at magazines, and hung out at Max's Kansas City. He met Andy Warhol and his friends there, sometimes sharing his loft with Edie Sedgwick. He had his own radio show and worked for record companies. He worked with the Velvet Underground, he signed and managed Iggy and the Stooges, signed the MC5, and managed the Ramones. Danny moved into this apartment in 1978 and lives there still.

"New York City is OK for America, but barely. It was OK in the '60s and '70s, then grew increasingly mediocre. It's a chore to go outside and have to see New York's very depressing population. My apartment will do—it has to. There was a great view of the river, now obliterated by a hideous, pretentious apartment building. The neighborhood is so run down and listless, and whatever the opposite of vibrant is. Vacant storefronts are the symbol of Greenwich Village now. I joined the Far West 10th Street Association because so much garbage was uncollected. We put out a little newspaper, which was cute: The Far West 10th Street Times. The garbage is still uncollected, food is three times as expensive as in London, and shopping for it is a terrible thing. It's a pity one has to eat to stay alive."
—Danny

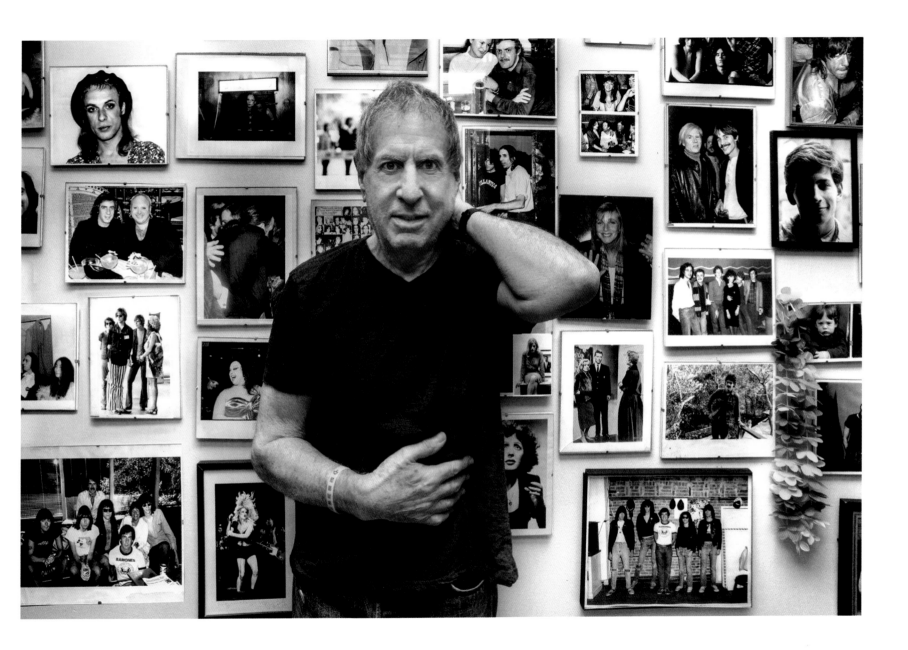

SALLY DAVIES

Photographed with her dog Bun at her home in the East Village on January 1, 2020.

Sally was born in 1956 in Winnipeg, Canada, the second of four kids for Mable and the third of five kids for Trev. Mom ran the household and when Dad worked he was a traveling salesman. She was anxious to get out of Winnipeg very early on. She ran away when she got her first tricycle, but only got a mile away to McCrindle's Gas Station when her mom found her. Sally did OK at school, excelling at art and volleyball. In Grade 4 she drew the cover for the school newspaper. She spent her childhood watching the Northern Lights from the backyard and skating 1.9 miles to and from school when it was 35 below zero. In 1972 Sally left home. She worked at a drugstore, ran a mail-order business for transvestite lingerie that she sewed, rescued dogs from the local shelter and sold them, hitchhiked around the continent as people were still doing in those days, and finally ended up in Toronto. She got a job straight away there, as a receptionist at an agency that booked strippers. Sally also went to art college for two years before moving to New York City to finish that degree. She settled quickly in the East Village because the rents were cheap and lived in Allen Ginsberg's old apartment on 2nd Street for seven years. She worked as a house painter, as a clerk in a retail store, and as a bartender to help pay school bills, serving drinks to the East Village artists and dealers. Sally exhibited her paintings at art galleries from the early '90s until 2004, then she quit painting and focused exclusively on her photography. She moved into this apartment in 1999 and lives there still. She believes in things we can't see and UFOs.

"I don't love everything about New York City, but what I do love has kept me here for almost 40 years. It was a place where you could disappear while you figured things out. I love the diversity and how we all live here together, with good days and bad days, like some giant dysfunctional family. I am lucky to have lived here in the magical, nutty old days, before it all got so bourgeois."
—Sally

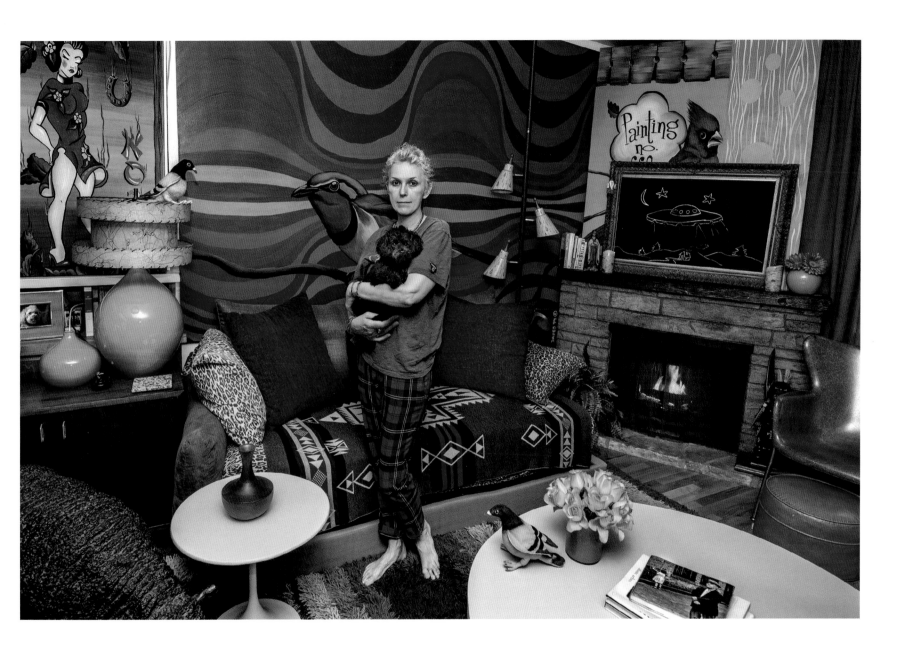

ACKNOWLEDGEMENTS

Thank you
Mable Davies, Don Watts, and Stan Watts for your never-ending help and encouragement.

Thank you
with gratitude and big love
to my comrades for your endless patience and tireless support in every way imaginable:
Jim Budman, Diane Bald, Claire Jeffreys, Kate Maxwell, Sean Corcoran, Michael Ernest Sweet, Jim Cuddy and Rena Polley,
Phil and Thea Scotti, Karin Piett, Tom Storey, Janet Halpin, Alex Witchel, Beatrice Moritz, Virginia Bell, Michael DeJong,
Bruce Mazer, Steven Greenfield and Alan Ibbotson, Gracie Mansion, Marvin Taylor, Frances Pilot, Christopher Bryson,
Marion Fasel, and Carolyn Newhouse—I'll be looking at the moon, but I'll be seeing you.

Thank you
Andy Warhol who told me in the men's bathroom one night in 1985 at the Odeon Restaurant,
"Decide what you want to do and just do that. Don't pay any mind to what the art world is
talking about. Just get really, really good at what you're doing and by the time they come around to
what you do, you'll be the very best at it."

Thank you
Jason Hook for appearing in my life like magic, knowing these people needed to be a book before I knew.
Stuart Horodner for your friendship, your extraordinary sense of humor, and your brilliance.
Robin Shields for letting this book find its voice with your beautiful design.
Laura Paton for your editing.
Jonathan Bailey for connecting all the dots.

Finally, and with so much gratitude,
Thank you
to each and every New Yorker for inviting me into your home to record your story and take your photo.
There is no one like you anywhere.

AMMONITE
PRESS

www.ammonitepress.com

BIOGRAPHIES

Sally Davies is a street photographer whose works are in the Museum of the City of New York and the 9/11 Memorial Museum. She is the author of the acclaimed McDonald's Happy Meal project (1.5 million online hits) and her archive is part of the Downtown Collection of Fales Library at NYU. She took Allen Ginsberg's old apartment when she moved from Canada to New York in 1983, and she still lives in the East Village with her dog Bun.

Stuart Horodner is director of the University of Kentucky Art Museum. He has held positions as artistic director at the Atlanta Contemporary Art Center; visual arts curator at the Portland Institute for Contemporary Art; director of the Bucknell University Art Gallery; and was co-owner of the Horodner Romley Gallery in New York City. His writing has appeared in periodicals including *Art Issues*; *Art Lies*; *Art on Paper*; *Bomb*; *Dazed & Confused*; *Sculpture*; and *Surface*. Horodner's book, *The Art Life: On Creativity and Career*, was published in 2012 and addresses the philosophical and practical issues that affect art-making and the marketplace.